COMPILED BY JEAN-CLAUDE SUARES
DESIGNED BY SEYMOUR CHWAST

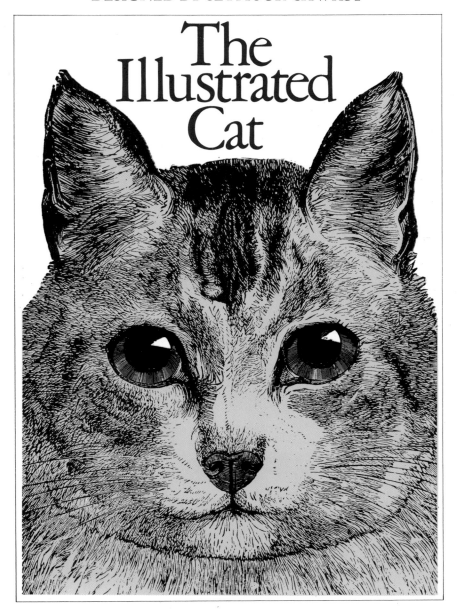

The Illustrated Cat

EDITED BY WILLIAM E. MALONEY

A Push Pin Press/Harmony Book

Harmony Books
New York

 A PUSH PIN PRESS BOOK
PRODUCED FOR HARMONY BOOKS

Push Pin Press

Producer: Jean-Claude Suarès
Editorial Director: William E. Maloney
Design Director: Seymour Chwast

Harmony Books

Publisher: Bruce Harris
Editor: Linda Sunshine
Production: Gene Conner, Murray Schwartz

Harmony Books
A division of Crown Publishers, Inc.
One Park Avenue
New York, New York 10016

Published simultaneously in Canada by
General Publishing Company Limited.
Printed in Japan by
Dai Nippon Printing Co., Ltd., Tokyo.

Library of Congress Cataloging in
 Publication Data
Suarès, Jean-Claude.
 The illustrated cat.
 1. Cats in art. 2. Posters. I. Chwast,
Seymour, joint author. II. Title.
NC1810.S82 1976 769'.4'32
 76-22694
ISBN 0-517-52644-1
ISBN 0-517-52643-3 pbk.

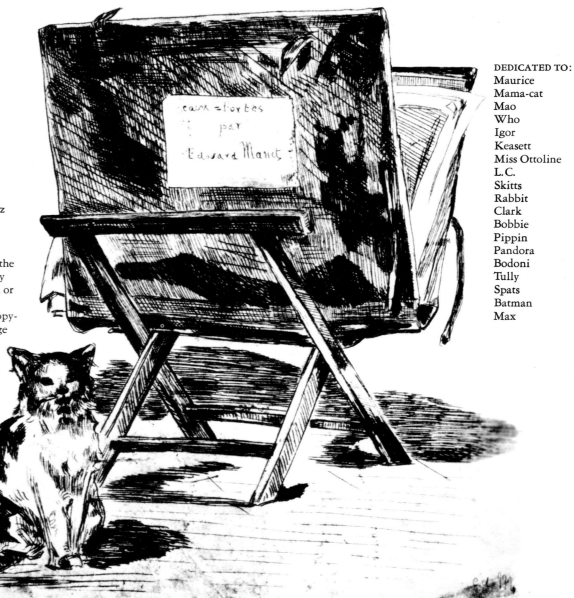

DEDICATED TO:
Maurice
Mama-cat
Mao
Who
Igor
Keasett
Miss Ottoline
L.C.
Skitts
Rabbit
Clark
Bobbie
Pippin
Pandora
Bodoni
Tully
Spats
Batman
Max

Strong and beautiful, beloved and independent, relaxed and alert, a cat walks into a person's life and takes over. A cat will make itself at home wherever it happens to be. Closets, drawers, furniture, windowsills, refrigerators, and hearts all fall into its paws without struggle. Rarely frustrated or confused, cats don't try, they just do. Unlike dogs, they avoid the traps and snares of devotion, protection, and fidelity. Cats are always perfectly dressed in the basic fur of all seasons, the cat's pajamas. These combine comfort with elegance and warmth with style. The pampered feline enjoys not merely the best of both worlds, but the best of all worlds.

Cats have been alternately revered and despised by man throughout history. These attitudes have been reflected in art and literature. In ancient Egypt the cat was considered both practical and divine. The practical cat is shown near blue waters, pursuing birds and fish, all action or suspense. The divine cat, immovable, eternal is captured in bronze and clay, a figure of unearthly beauty—sphinxlike in its enigmatic gaze. The cat was sacred to the chief deity, the sun-god Ra, and to the chief goddess, Bastet. The goddess deity is sometimes depicted as a woman with the head of a cat. One wonders if her unblinking eyes see beyond eternity or are simply fixed on a mouse.

Cats performed other functions in Egyptian life and folklore. Because they were believed to protect the harvests, they were established in homes as household gods and reigned as the presiding spirit of the home—the *genius loci.* They were also regarded as guardians of the human spirit in the hereafter, acting as spiritual guides in the next world. Their sacred bodies were often treated with greater reverence than those of people. They were carefully embalmed and buried in special cemeteries. (Hundreds of thousands of these cat mummies were excavated in the nineteenth century and exported for use as fertilizer.)

The Greeks believed that the moon goddess, Artemis, created the cat in retaliation for the lion her brother Apollo, the sun-god, created to frighten her. This tie to the obscurity of night was to cause endless trouble for the cat in the later Middle Ages. With

Edouard Manet made the 1870's sketch on the opposite page, seeing to it that the art portfolio in his Paris studio was guarded by his favorite cat. On this page, far left, is an ancient Egyptian feline, crafted about 500 B.C. It watches over the spirits of the dead. On the left is a book cover for *The 3 Little Kittens,* a tale that demonstrates how the domesticated cat helps to domesticate children.

the emergence of Christianity and its rejection of any other deities, the association of the cat with freedom, independence, and the happy home—all common from the earliest civilizations to the time of the Roman Empire—was replaced by images of fear and witchcraft. Cats became demonic symbols of worship for those who participated in the frightful Black Mass ceremonies.

All of the qualities that had placed the cat in its position of esteem for thousands of years were suddenly turned against it. Its aloofness was translated as false pride, its sleep became Satanic, and its unblinking gaze was likened to the devil's eye. Its grace was compared to that of Eve, who seduced Man to his fall. Cats became symbols of lust, greed, stealth, deception, and indolence. Like witches, they were burned or drowned as agents of evil. Their very existence was considered a threat to morality, law and order.

With the discovery of the New World, things began to change for *Felis catus*. What brought the cat back to home and hearth from its sojourn in hell? Money. With new sea routes opening to both the Far East and the New World, cats were needed on ships, to kill rats that added disease and death to cargoes of spices, silks, and jewels. Restored to their old glory by this renewed service to man, cats once again began to enjoy the role of guardians of the household at home and at sea. Just as their alert gaze and ingenious ways had linked cats to witchcraft, now these same qualities tied them to shrewdness and inventiveness.

The beloved tale of *Dick Whittington and His Cat* represents the cats return to popular favor. Being a poor lad, Dick had nothing to take to sea but his cat. The ship that they sailed on was wrecked in the Orient, and Dick and his puss found themselves in a foreign kingdom infested with rats and mice. The cat sprang into action and frightened away all of the unwanted rodents. The grateful king promised to fill Dick's coffers with gold, if only he consented to leave his cat. Dick agreed and upon his return home was made Lord Mayor of London. In appreciation, Dick included the cat's name in his new title. A monument to Dick's worthy animal now stands prominently on Highgate Hill in London.

The story *Puss in Boots* also features a shrewed feline hero. The youngest son of a nobleman is left with no inheritance

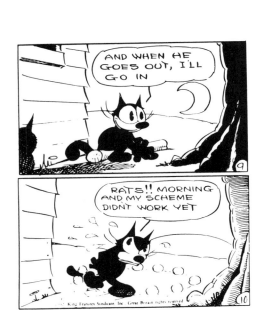

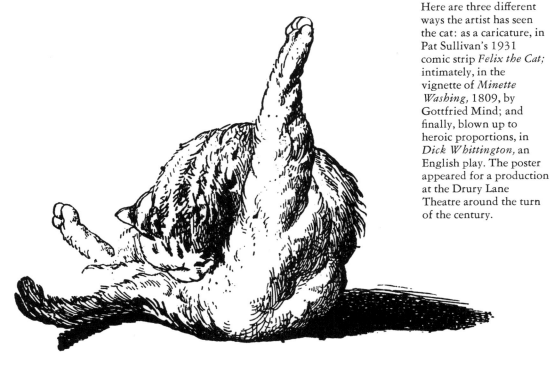

Here are three different ways the artist has seen the cat: as a caricature, in Pat Sullivan's 1931 comic strip *Felix the Cat;* intimately, in the vignette of *Minette Washing,* 1809, by Gottfried Mind; and finally, blown up to heroic proportions, in *Dick Whittington,* an English play. The poster appeared for a production at the Drury Lane Theatre around the turn of the century.

except for his father's cat. The clever cat, Puss in Boots, proves to be worth more than gold as he leads his master to wealth, title, and a beautiful bride, even outwitting a fearful giant along the way. Puss in Boots is rewarded by his master with the softest, happiest home a cat could desire.

The virtues of the cat have continuously delighted writers of children's books. The cat set a good example: neat and clean, tidying up after itself, bringing up kittens with constant care and vigilance. Millions of cats sat on well-scrubbed mats looking after kittens who'd lost their mittens. Such cats filled the school texts and fairy tales of the nineteenth century. Cats came to represent the middle-class virtues of caution, thrift, and order.

Time passed and cats took on even comic images. First, there were the Katzenjammer Kids who spent their lives devising ways to plague a pussy. Then along came Krazy Kat, the zaniest of all felines. As the world became ever wilder, so did the cat and mouse game. Walt Disney made a hero of a mouse, and the cat was returned to its medieval self as it deviled poor Mickey to within an inch of his tiny life. Today, we can be amused by the droll cats created by Ronald Searle, and no one will ever forget the grinning Chesire from *Alice in Wonderland*.

Of all the nations in the world, France has had the most abiding love for cats. No people has loved cats with more devotion. Beginning with the great poets of the sixteenth century, French writers and artists have been celebrating the beauty, sensuality, and mystery of their favorite animal. The cat came to represent all that they loved best in women. Unpredictable, ready to purr or pounce, aloof yet passionate, elusive but with its feet in the ground, the cat symbolizes the enigmatic and endearing qualities of Woman.

Cats have been used to symbolize gods, human virtues, demons and women. They have been represented in poetry, prose, art and song. They have even been used to sell fruit (see page 61).

How do our feline friends respond to these generations of demeaningly human comparisons, be they sentimental, sexist, or demonic? As they have for centuries, cats respond with a quick wink of a golden eye, a distainful flick of a tail, or a quietly amused purr, and leave man wondering.

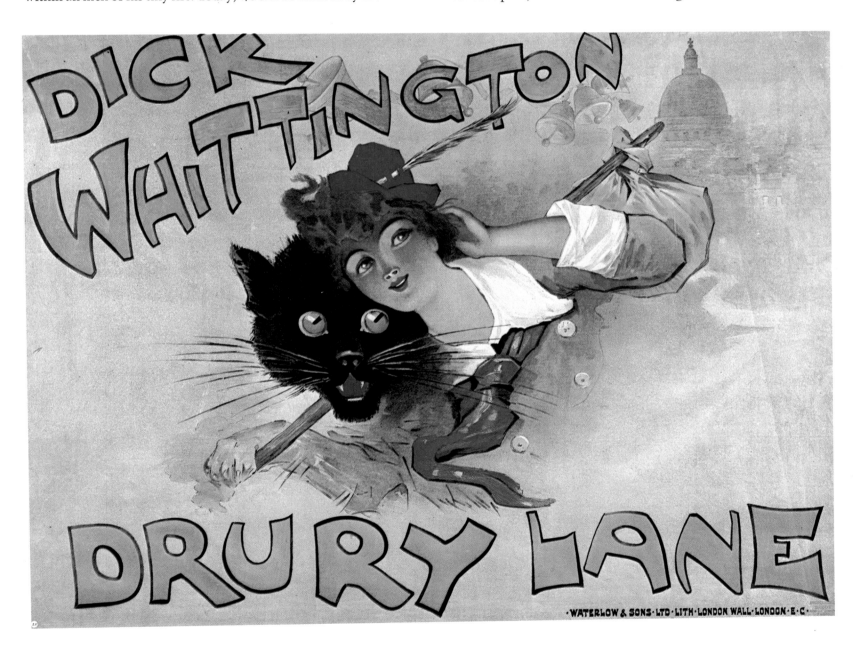

Opposite: In the fifteenth and six-
teenth centuries the cat came under
careful study by artists and natural-
ists. Ulissi Aldovrandi painted this
watercolor around 1580. *Below:* The
woodcut of this alert cat is from *The
Historie of Four-Footed Beastes,*
compiled by Edward Topsall for a
London publisher in 1658.

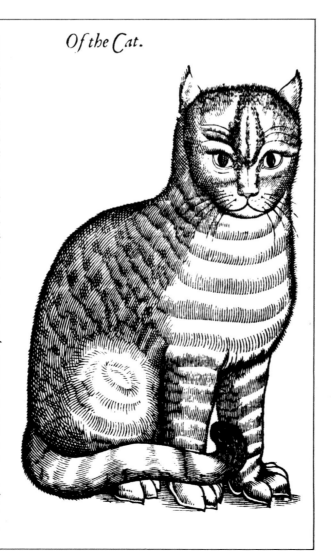

Of the Cat.

coulde haue reftrained
them from that fury, had
not the King himfelfe &
his greateft Lords come
in perfon, not fo much to
deliuer the Roman Cat-
murderer, as to fauegard
him from the peoples vio
lence; and not onely the
10 Egyptians were fooles in
this kind, but the Arabi-
ans alfo, who worfhipped
a cat for a God; and when
the cat dyed, they mour-
ned as much for her, as
for the father of the fami
ly, fhauing the hair from
their eye-lids, and carry-
ing the beaft to the Tem-
20 ple, where the Priefts fal-
ted it and gaue it a holy
funerall in *Bubaftum*:
(which was a burying plaf
for cattes neer the Altar)
wherin may appeare to al
men, in what miferable
blindneffe the wifeft men
of the world, (forfaking,
or depriued of the true
30 knowledge of God are,)
more then captiuated, fo
that their wretched eftate
cannot better bee expref-
fed then by the words of
S. Paule, *When they thoght
to be wife, they becam fools.*

6

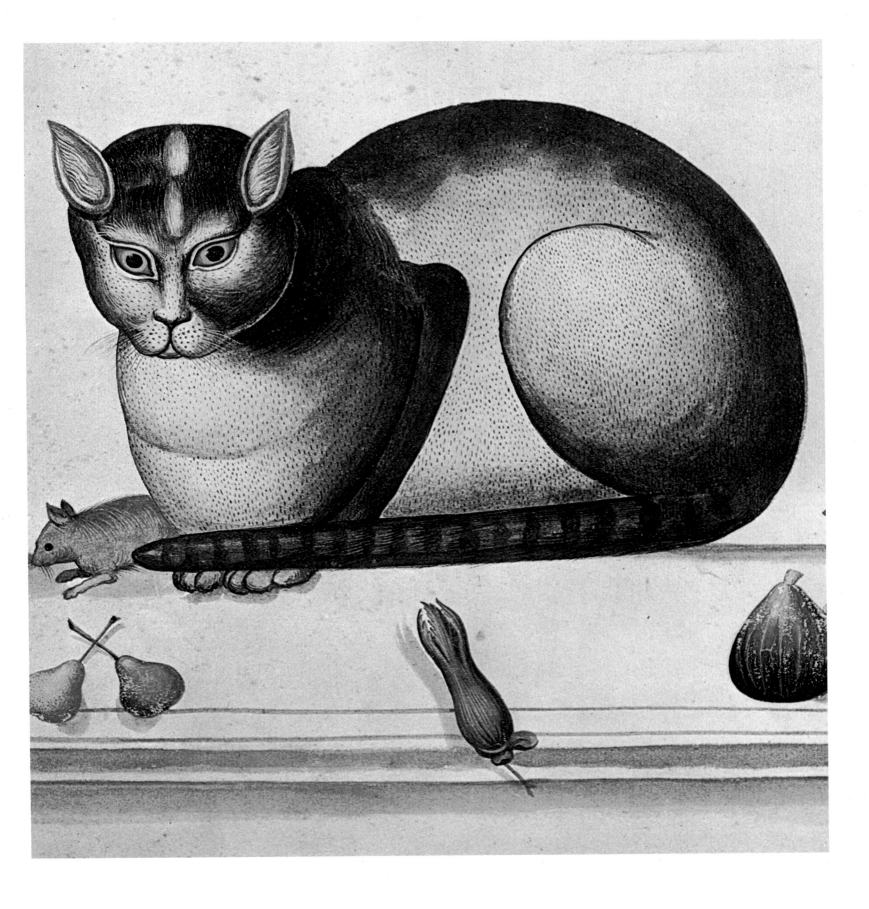

Remote and mysterious, cats were often thought to aid witches and magicians in their mastery of the demonic and supernatural. *Opposite:* In a tarot card designed for a James Bond film, a cat lends atmosphere to the art of the magician. *Below:* A cat assists Satan in his devilish work. *Bottom:* The Austrian artist Alfred Kubin delineated in the 1930's a frightful creature—*Der Katzen-mensch,* which is both man and beast, an insult to any self-respecting cat.

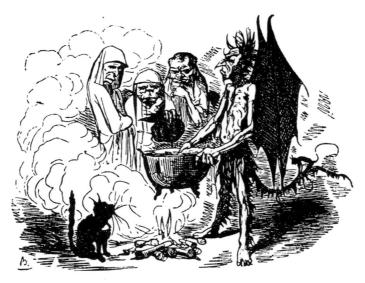

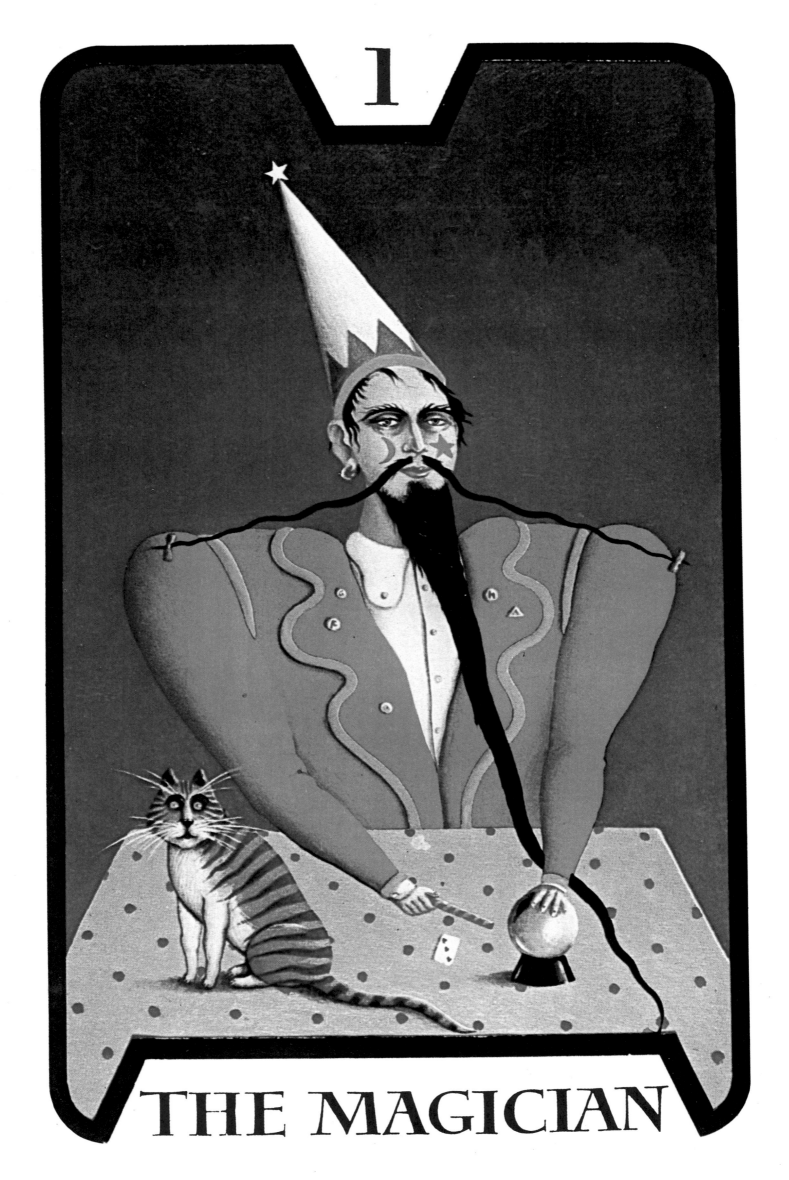

The print below is adapted from an
early eighteenth century work by the
great French artist Antoine Watteau.
Titled *The Sick Cat,* it makes fun of
a lady's love for her mean pet, as the
pampered darling attacks the vet
who tries to save its evil-tempered
life. *Opposite:* The English carica-
turist George Cruikshank drew this
devastating plague of cats about the
middle of the nineteenth century,
as they catch a quick bite of supper
and proceed to destroy the kitchen.

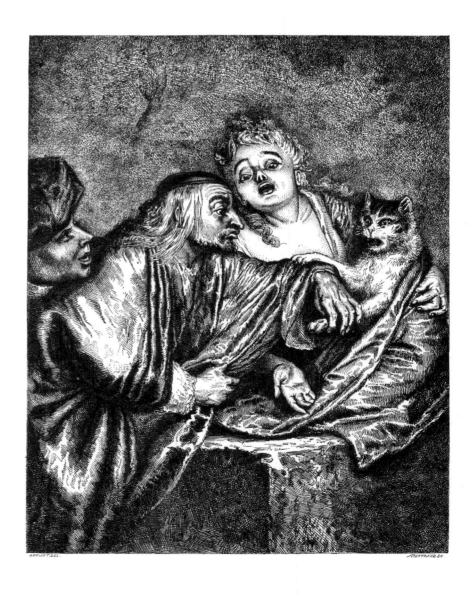

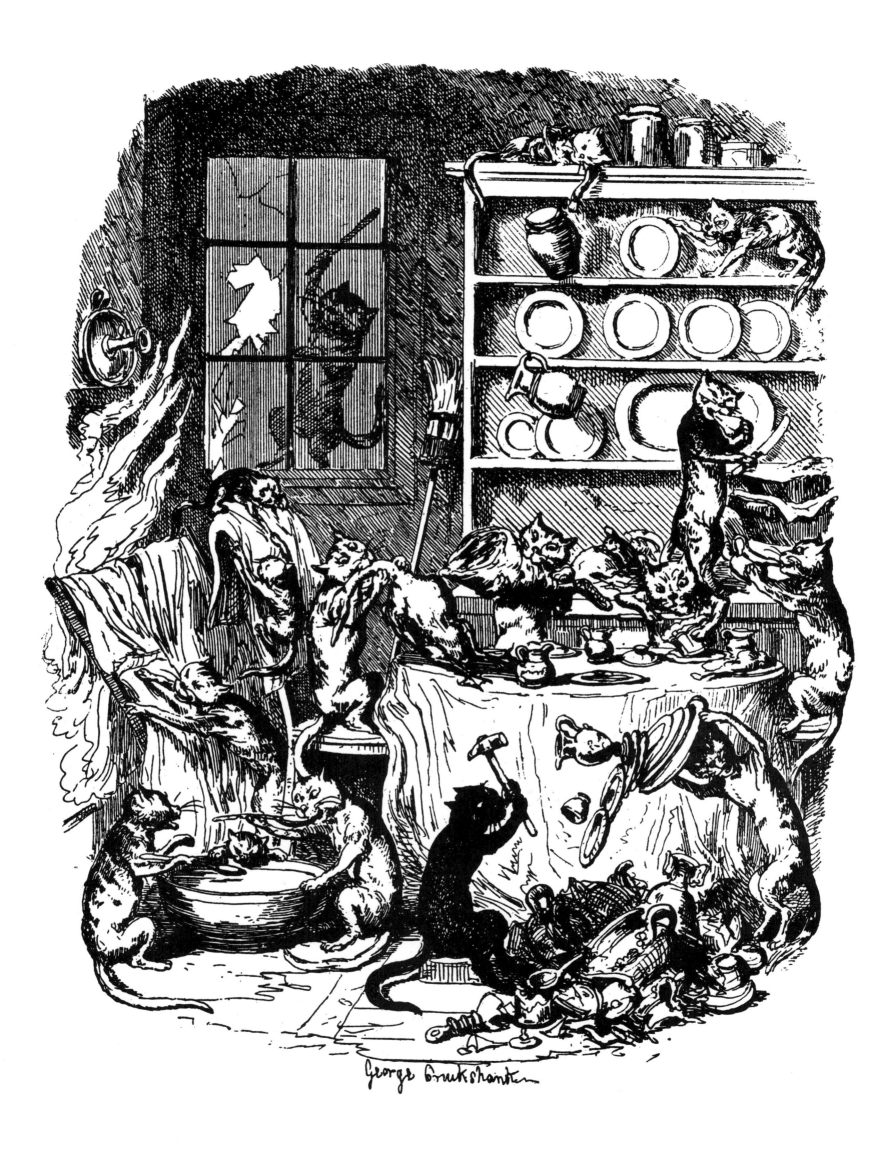

George Cruikshank

Opposite: J. B. Greuze painted this sensuous *Wool-Winder* in 1759. Is the lady as demure as she looks, or does she see beyond the naughty cat toying with spools of yarn on her lap, recalling quite different games? *Below:* Kneeling to feed a regal feline, this French lady was painted about 1800, when fashions and furnishings of Greece and Rome were brought back to suit Napoleon's new imperialism.

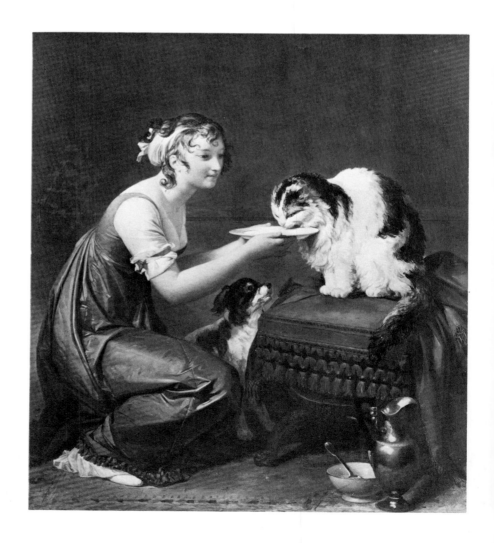

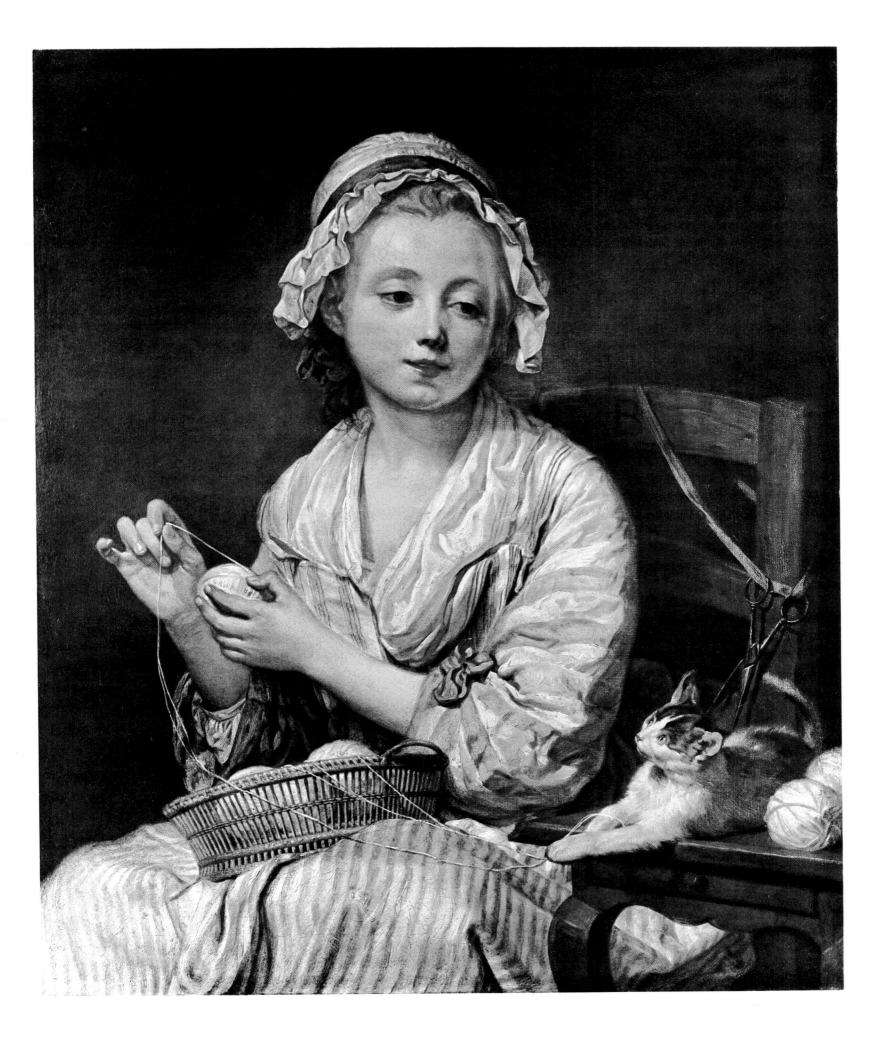

The art of Francisco Goya includes reason and the irrational, convention and criticism. *Opposite:* Little *Don Manuel Osorio de Zuñiga* poses around 1788 in his Sunday best with his pet bird and cats, in much the same way as American artists showed children of prosperous farmers and storekeepers. The etchings below are from the Spanish master's etched series *Los Caprichos* (1796–98), a frightful voyage into the world of insanity. Here cats represent the demonic spirits of witches and warlocks lurking within all of us.

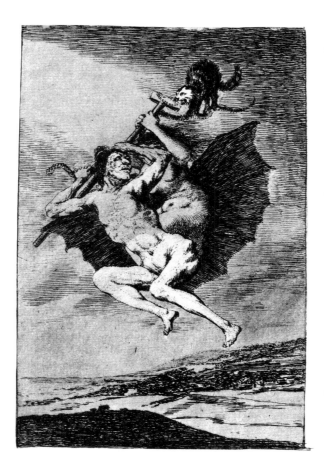

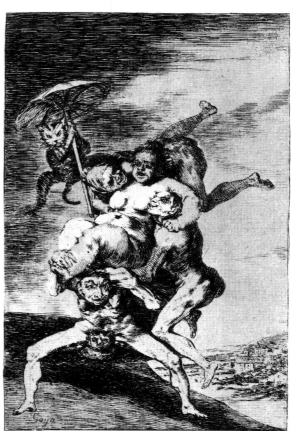

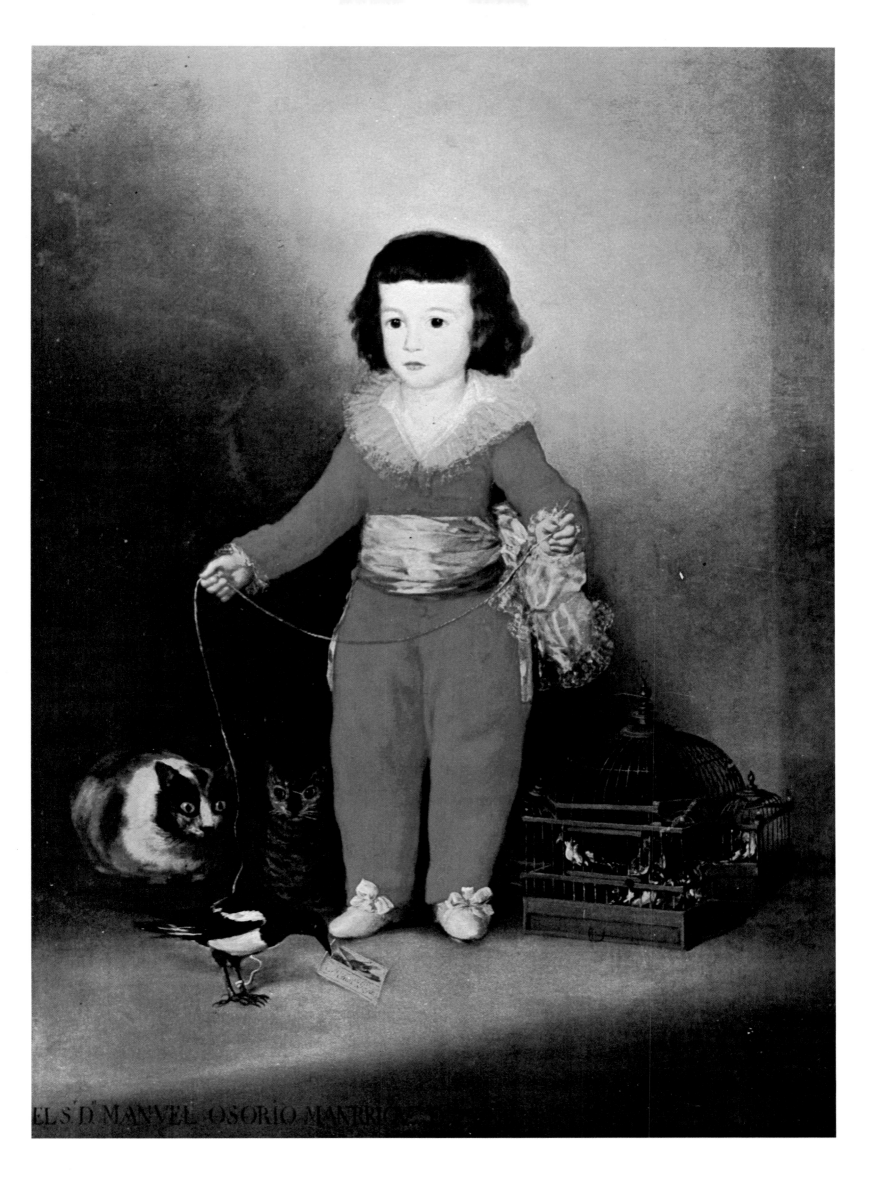

ELS DᵈMANVEL OSORIO MANRIC

Below: Grandville (pseudonym for J. I. J. Gerard) provided the most imaginative and delightful illustrations of all masters of animal portraiture. Like Aesop, he used beasts to tell the truth about people. He did it in such an irresistibly witty way that everyone could see his own foibles and pretenses in the drawings, which were done about 1840.
Opposite: Gustave Doré, heir to Grandville's art and audience, drew this magnificent *Puss in Boots* to illustrate the edition of Perrault's fairy tales, published in 1862. Here the foxy cat appears at the beginning of the plot, calling for help as his silent partner crouches in the water, waiting for "rescue."

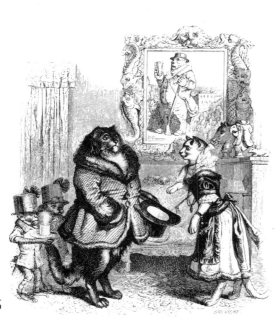

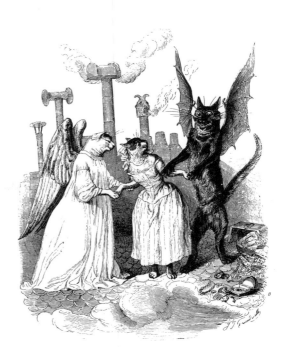

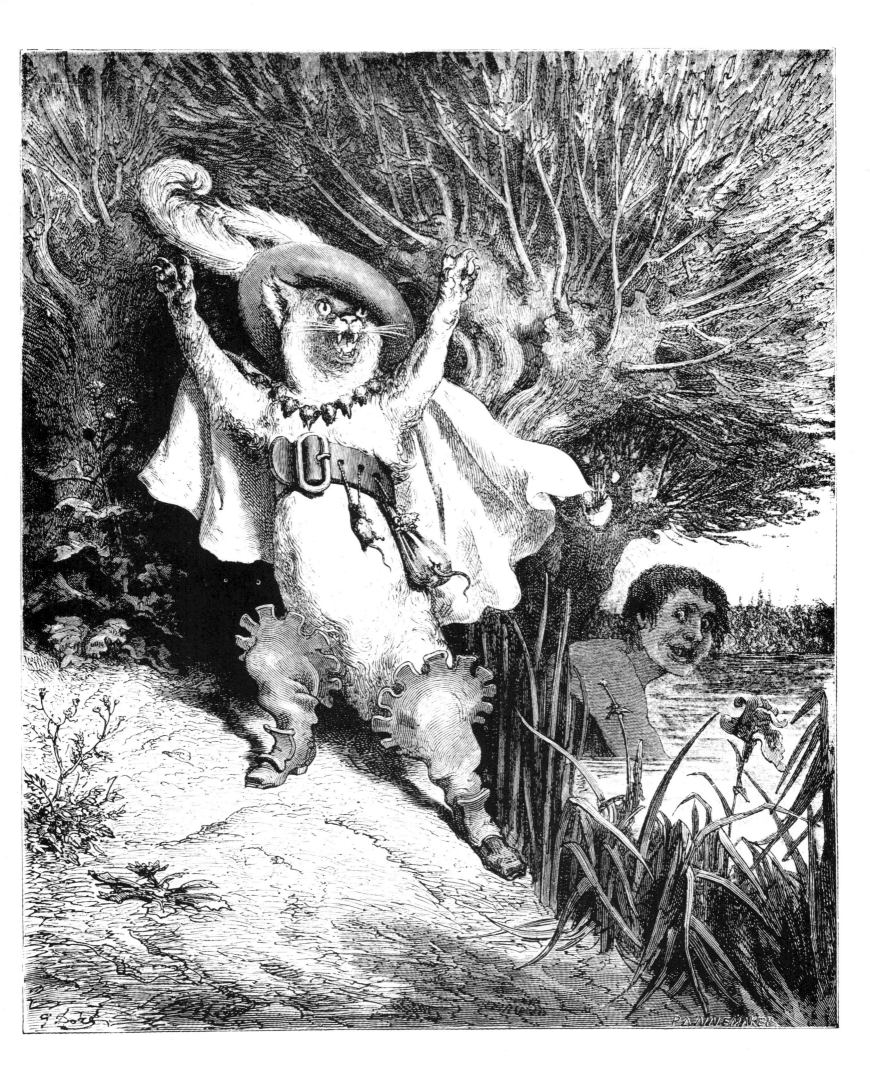

Opposite: Kitty, here delicately and cautiously poised, is the work of an anonymous American print-maker of the early nineteenth century. His naïve yet deliberate style is well suited to this country cat. *Below:* These elementary cats are taken from Lessons 1 and 6 of Lippincott's *First Reader* of 1882, where *all* four-letter words are forbidden.

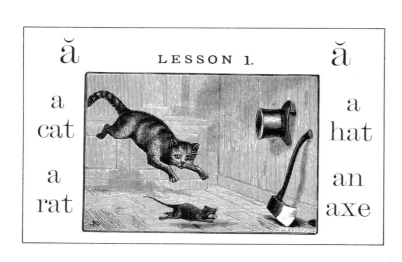

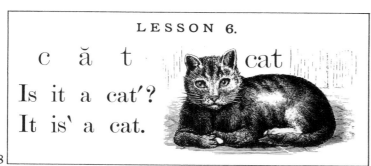

KITTY

Wilhelm Busch seized upon almost all that was funny and nasty in German middle-class life. In the drawings on this page, produced in the late nineteenth century, he succeeds almost too well in picturing the mean manners shared by pets and their masters. *Opposite:* A cat and a cock form an unlikely partnership as they set off on an adventure, in a European folktale.

Hypocritical Helen

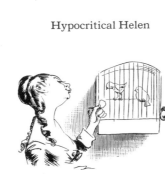

Now Helen at this crucial stage
Kept two canaries in a cage.

And here is Minzi, Helen's cat.

One day, to make a social call,
Comes tomcat Munzi, smart and tall.

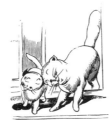

At once the cats are quite agreed
On the activity they need.

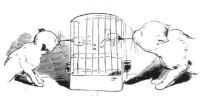

Each pulls a little head outside
And perpetuates canaricide.

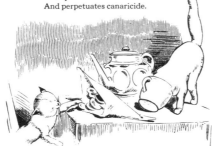

Then quite refreshed, feeling able,
They leap up on the coffee table.

Blindly, Munzi smashes to the floor.
Crash! The pitcher is no more.

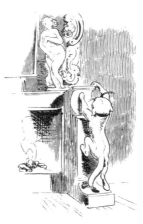

Here see him panic-stricken race
Aloft upon the fireplace.

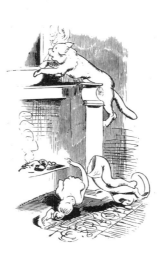

Alas, poor Venus! It was she,
Not Milo, but de Medici!

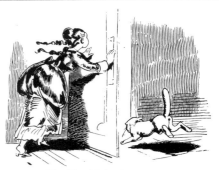

Now Munzi dashes for escape,
But finds he is a bit too late.

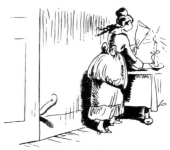

Munzi's caught! See Helen fetch
Means to punish the poor wretch.

The paper cone is twisted, right.
Around the tail, till it fits tight.

Then with a candle, set afire,
The flames mount, quickly higher.

Now Munzi's free to run—at last.
Mee-ow! The heat is rising fast.

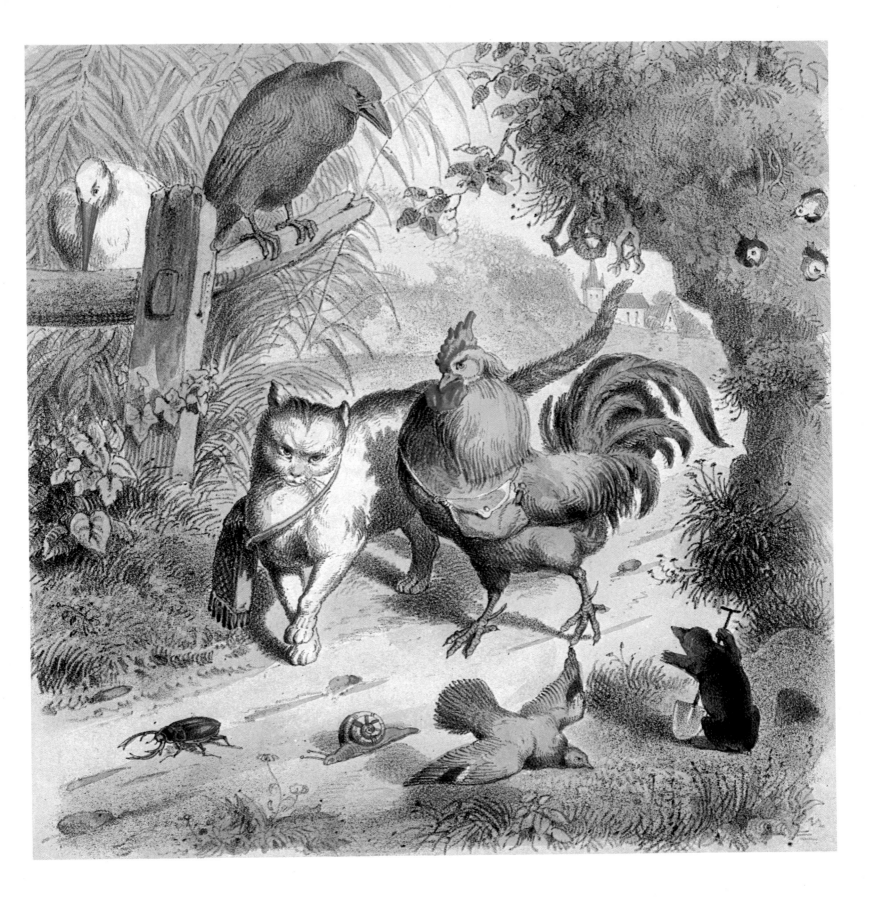

These fluffy cats pose proudly, almost disdainfully, regally, as though they had just acquired their thoroughly fancy furs. The chic pale pet below was drawn by Gustav Mutzel, in the late nineteenth century. The furry white odalisque opposite was painted by Morris Hirschfield in 1937.

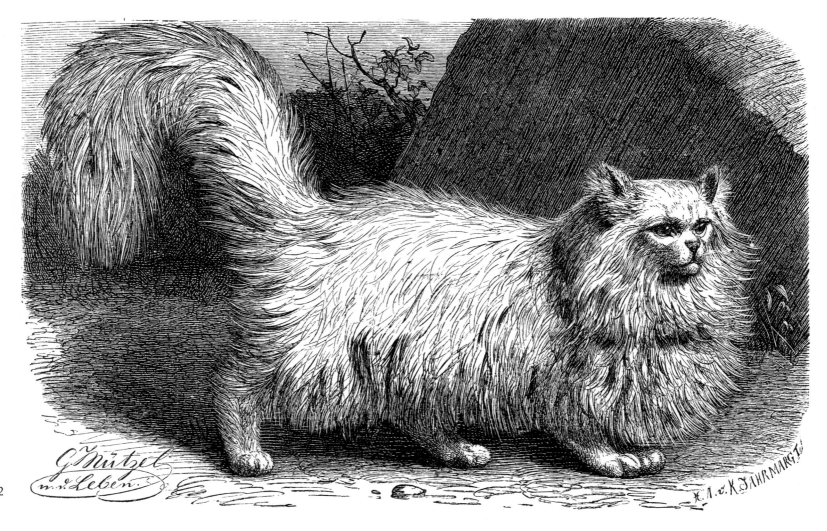

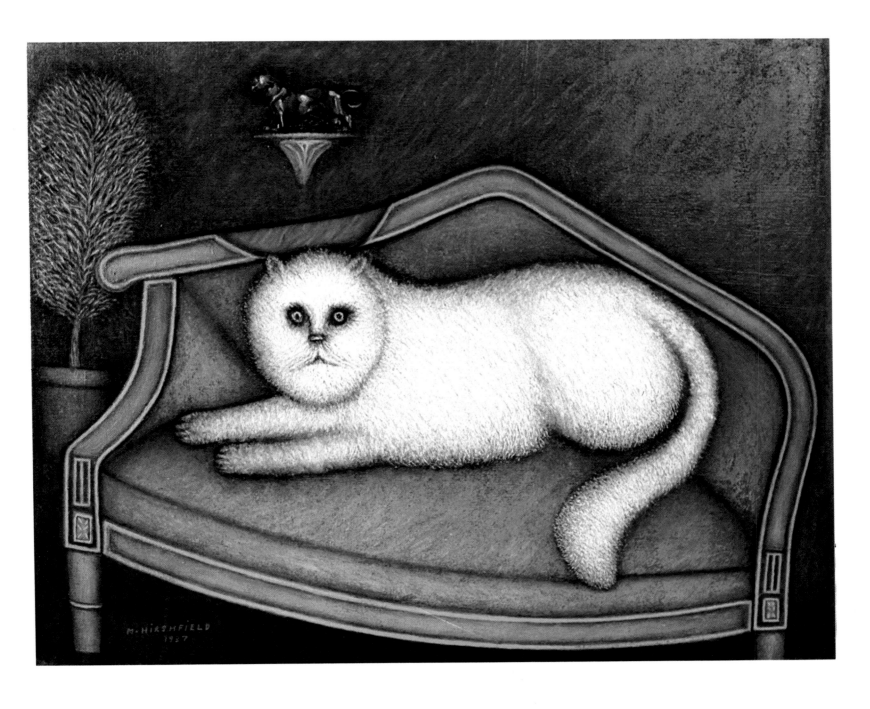

John Sloan, who loved the low life of New York, painted these alley cats *(opposite)* stalking the snowy jungles of *Backyards, Greenwich Village* in 1914. *Below:* In a style as crisp and clean as his writing, Rudyard Kipling drew this brisk silhouette of "The Cat That Went by Himself" for his *Just So Stories* of 1902.

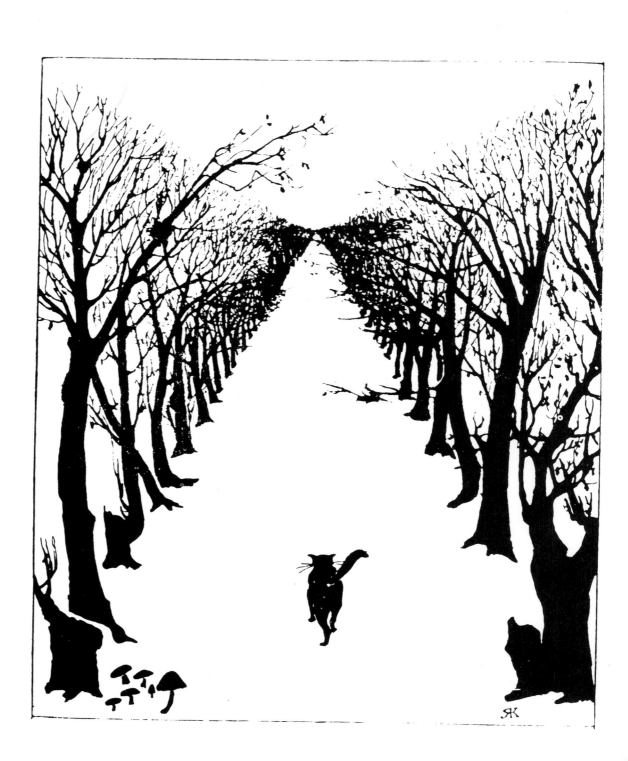

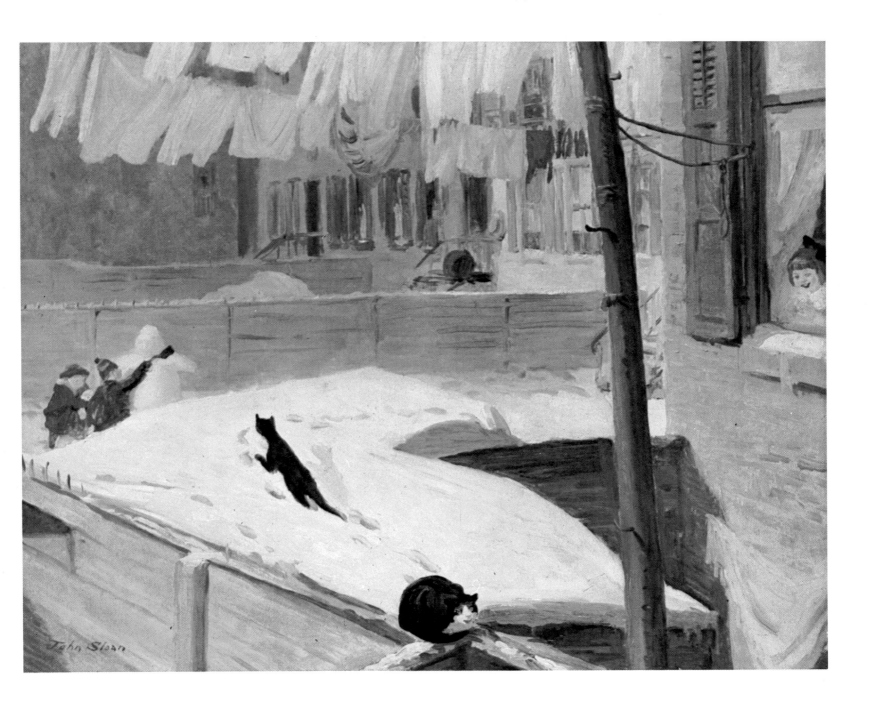

Minnie from the Outskirts of the Village (opposite page) is like some romantic heroine from a Gothic novel. She was painted in 1876 by R. P. Thrall. She peers uncertainly at the viewer, momentarily caught between Lost and Found. Her red and gold collar bespeaks a proud owner. She's a very settled cat, yet Minnie's strangely fixed gaze suggests a wanderlust for the vista beyond the river, beyond the outskirts of the village. Such cat pictures satisfied folk artists and their clients by combining the roaming spirit and the hearthside—the so-near with the yet-so-far. Paintings like the nineteenth-century works at the right were often created by journeymen artists. The pictures are (from top to bottom) *Kittens Examining a Mouse Swimming in a Milk Bowl* by Flora E. Bailey, 1883; *Cat with Mouse,* artist and date unknown; *Cats Playing with a Spool of Thread,* artist unknown, late nineteenth century; *Study in Gray and Black;* artist unknown, painted around 1875.

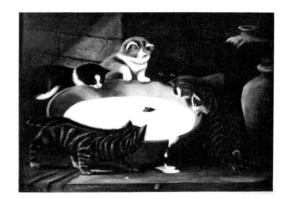

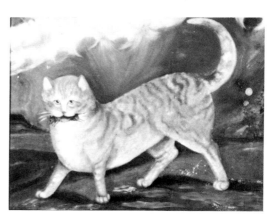

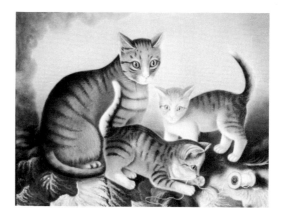

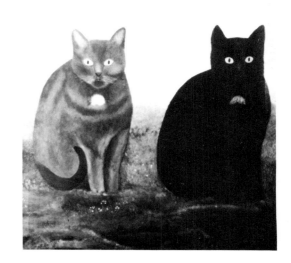

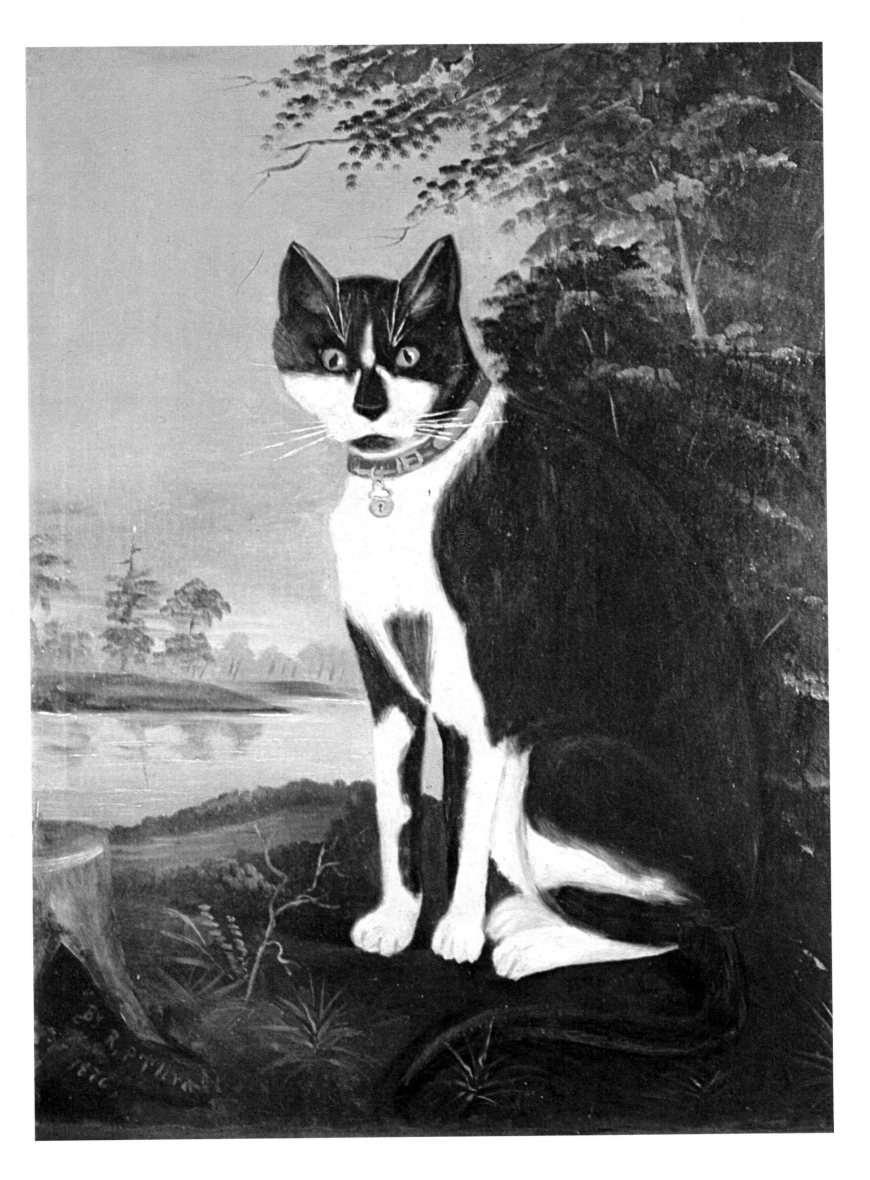

The eldery New England lady (*below*) with her Old Testament given name, Jerusha, fittingly christened her black tomcat "Lucifer," after the Bible's fallen angel. (Unknown artist, Massachusetts, ca. 1830.) Does her gaze suggest that despite her prim bearing she too might have a bit of the devil in her? And what of the Poor Little Rich Girl, oposite? She wears a party dress, yet she appears just as woeful and unhappy as her cat. How many long sittings for the artist did they suffer through, well over a century ago? William Thompson Bartoll painted their portrait around 1850.

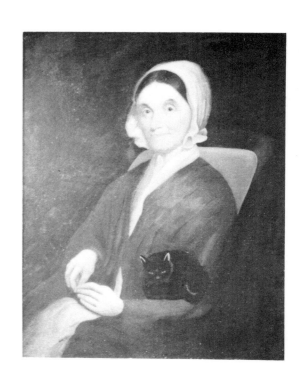

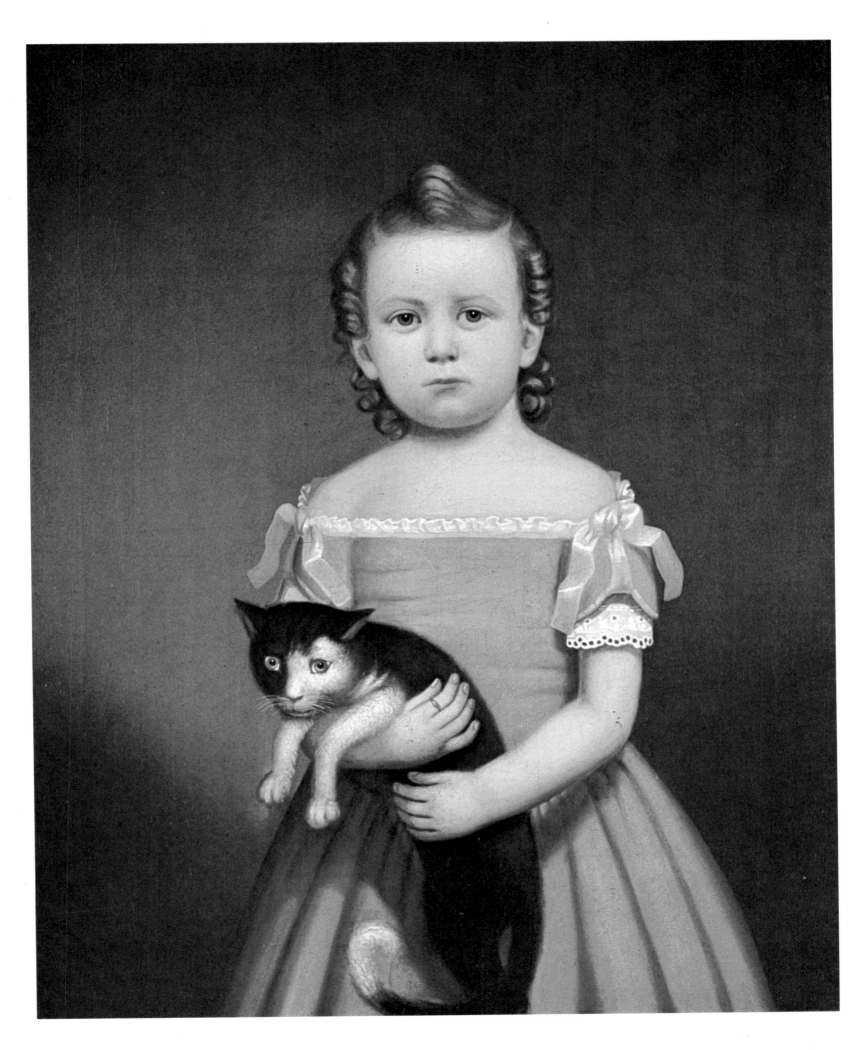

By holding tightly onto their cats or kittens, these nineteenth-century American children were able to contain their high spirits. The artists could then create for their parents and posterity these Little Ladies and Gentlemen. The charming painting (*opposite*) is by Ammi Phillips, ca. 1836. On this page, the painting at the left (you'll be surprised to know) is *Boy with Cat,* attributed to Joseph Goodhue Chandler, ca. 1845. Next to it, at the top, is *Girl in Blue with White Cat,* artist unknown, ca. 1820. Then, *Baby in Blue,* artist unknown, eighteenth-century. At the bottom, left, is *Little Girl in Lavender* by John Bradley, 1840. And, finally, the elegant *Girl with Cat.* In real life, she was Miss Catherine Van Slyck Dorr. It was painted by Ammi Phillips, ca. 1814.

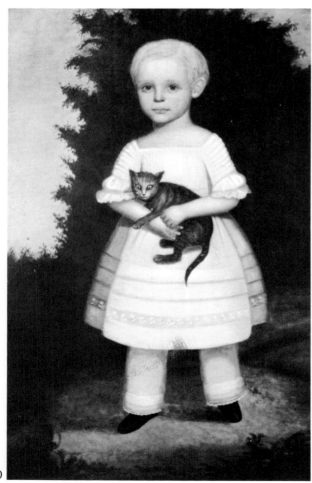

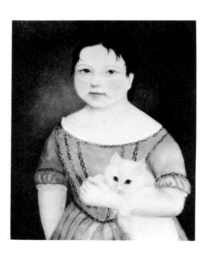

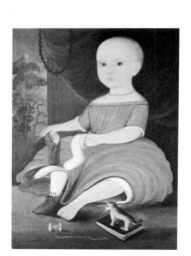

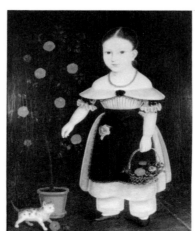

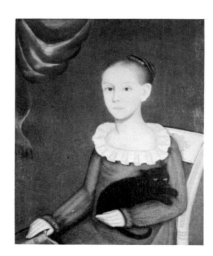

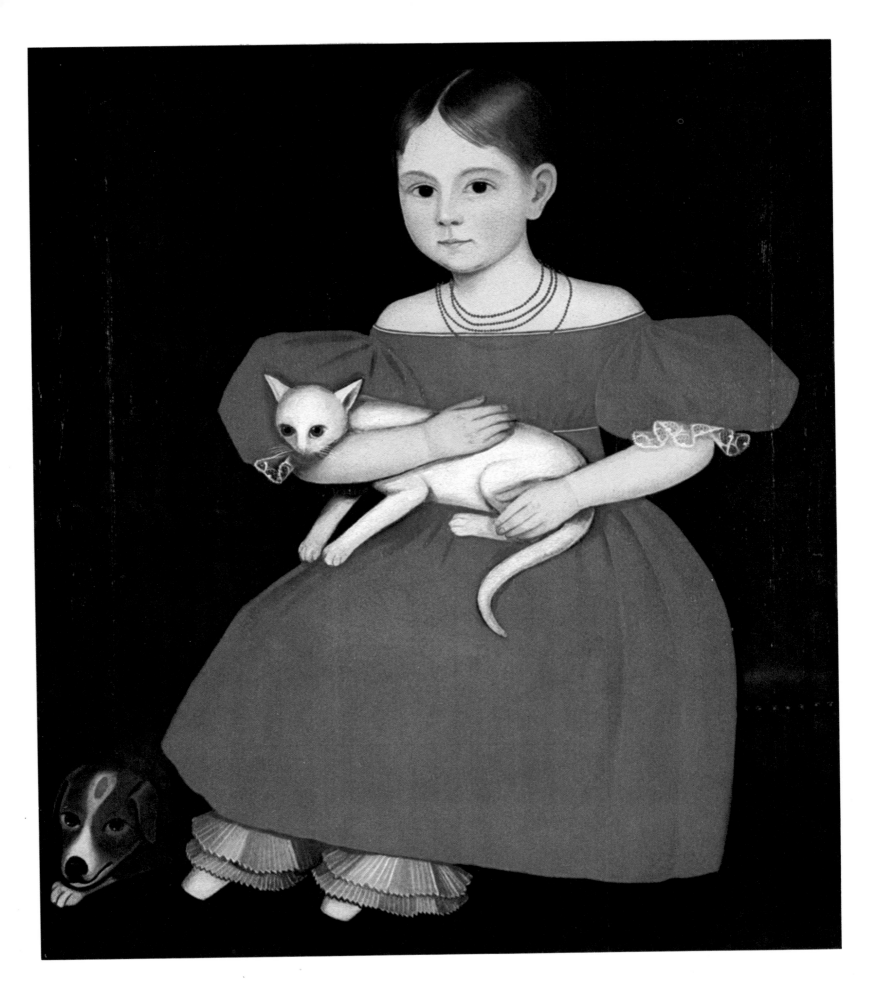

Cats are cherished in the Orient. As subjects, they are among the glories of Eastern art. Their sinuous profiles are well suited to calligraphic works in pen and brush. *Opposite:* Peering around the edge of a screen, motion suspended, a lovely Japanese cat bristles its whiskers at a spider. Is the cat merely curious, or does this tableau end in a small tragedy for the spider? This study was brushed on silk by the Japanese artist, Toko, in the nineteenth century. *Below:* More like pandas than pussies, these fat kittens loll playfully within a decorative Chinese garden, as they seem to stare, wide-eyed, at the artist. Titled *Spring Frolic in a T'ang Garden,* the painting is attributed to Hsüan Tsung, during the Ming dynasty.

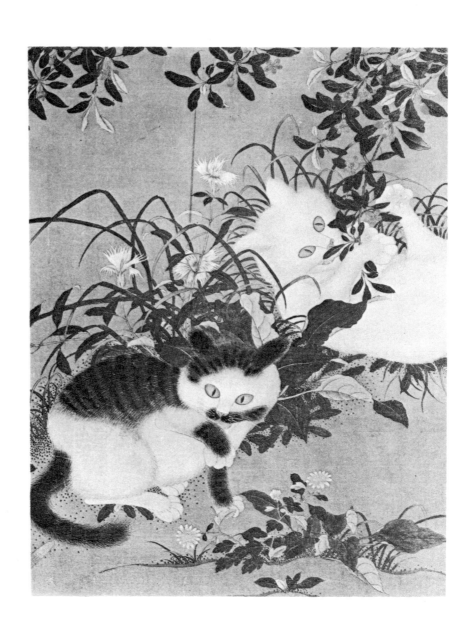

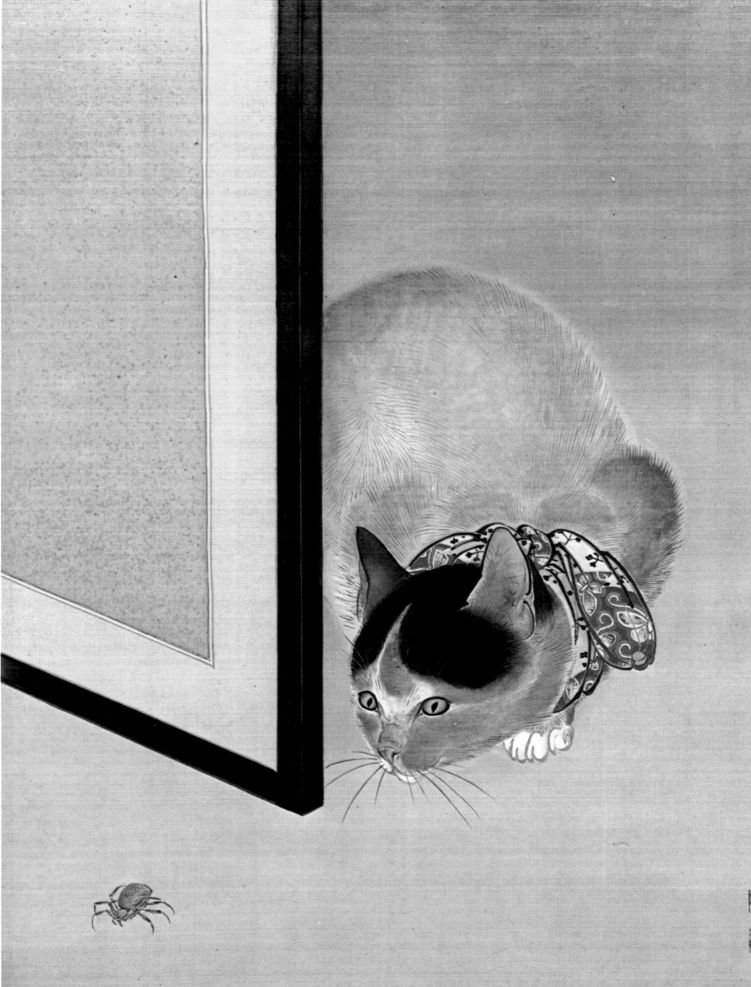

Again, the Orient probes the subtle mysteries of the cat. The charmer opposite was painted by the Japanese artist Hiroshige in the early 1800's. The cat seems to enjoy her reflection in the water, as she goes about washing her face. Can you detect the ghost of a Geisha-like smile?

Below: The feline mystery is further explored in this curious Japanese-style work which appeared in the French publication, *Les Chats,* in 1870. The composite head is formed of nine or more cats. (How many can you count?) Is the artist saying each cat has many faces? Or is he illustrating the myth that each cat has many lives?

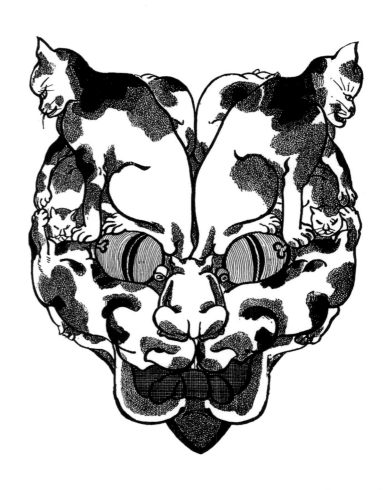

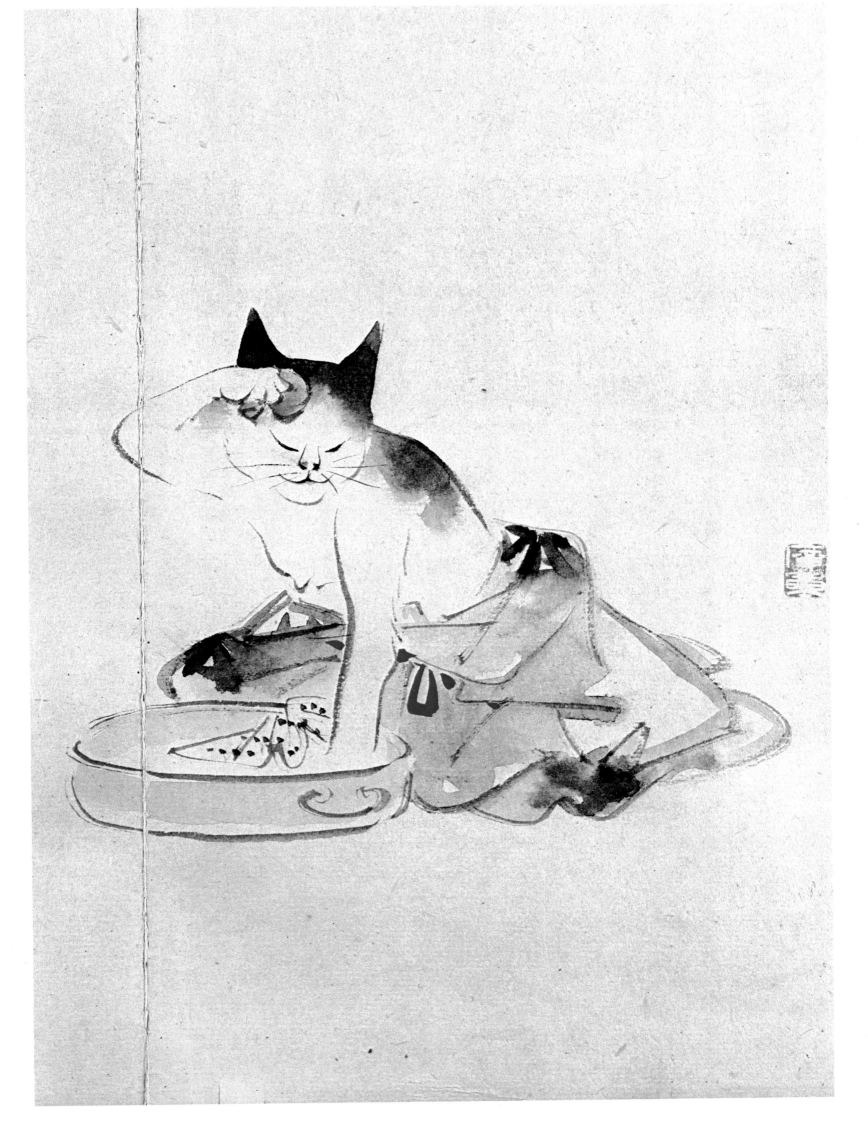

The first major study of cats, *Les Chats,* was written by a French journalist, Jules Husson, in 1870. He used the pen name Champfleury. His friend, Edouard Manet, provided a lithograph (*opposite*) which became the key piece of art for all editions. The scene seems to celebrate Paris, as two cats on a roof view each other with cautious excitement, tails twisted in passionate dialogue.

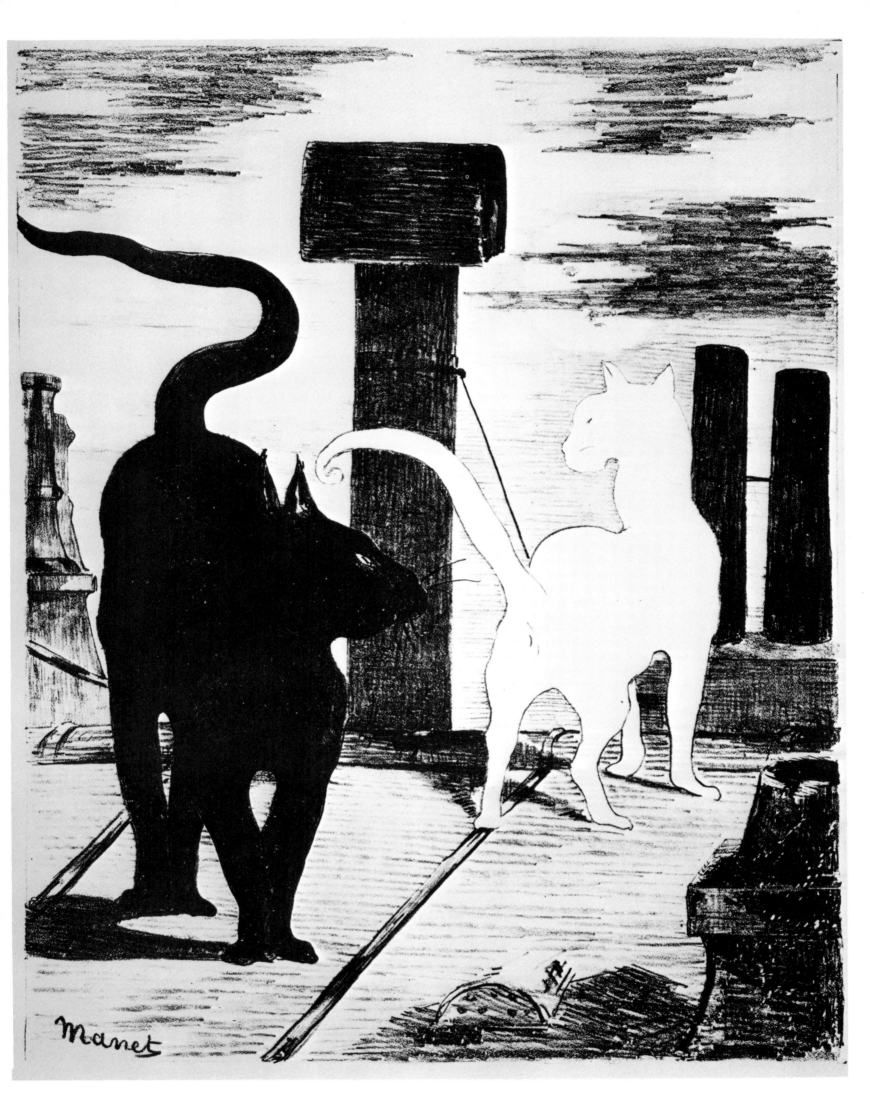

As everyone knows, the English are mad for cats and fond of nonsense. At right, Edward Lear, amateur poet and amateur artist, provided lines and drawings in 1871 as splendidly silly as any in the whole history of arts and letters. *Opposite:* John Tenniel brought Lewis Carroll's *Alice in Wonderland* and all her friends to life in 1865. The Cheshire cat smiles and smiles, in a daydream we have all shared for over a century.

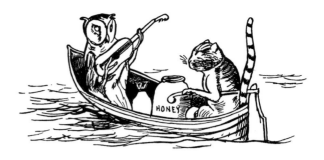

THE OWL AND THE PUSSY-CAT

I

The Owl and the Pussy-Cat went to sea
 In a beautiful pea-green boat,
They took some honey, and plenty of money,
 Wrapped up in a five-pound note.
The Owl looked up to the stars above.
 And sang to a small guitar,
'O lovely Pussy! O Pussy, my love,
 What a beautiful Pussy you are,
 You are,
 You are!
 What a beautiful Pussy you are!'

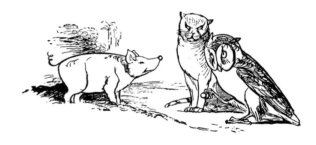

II

Pussy said to the Owl, 'You elegant fowl!
 How charmingly sweet you sing!
O let us be married! too long we have tarried:
 But what shall we do for a ring?'
They sailed away for a year and a day,
 To the land where the Bong-tree grows,
And there in a wood a Piggy-wig stood,
 With a ring at the end of his nose,
 His nose,
 His nose,
 With a ring at the end of his nose.

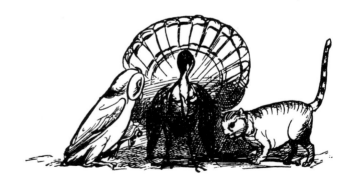

III

'Dear Pig, are you willing to sell for one shilling
 Your ring?' Said the Piggy, 'I will.'
So they took it away, and were married next day
 By the Turkey who lives on the hill.
They dinèd on mince, and slices of quince,
 Which they ate with a runcible spoon;
And hand in hand, on the edge of the sand,
 They danced by the light of the moon,
 The moon,
 The moon,
 They danced by the light of the moon.

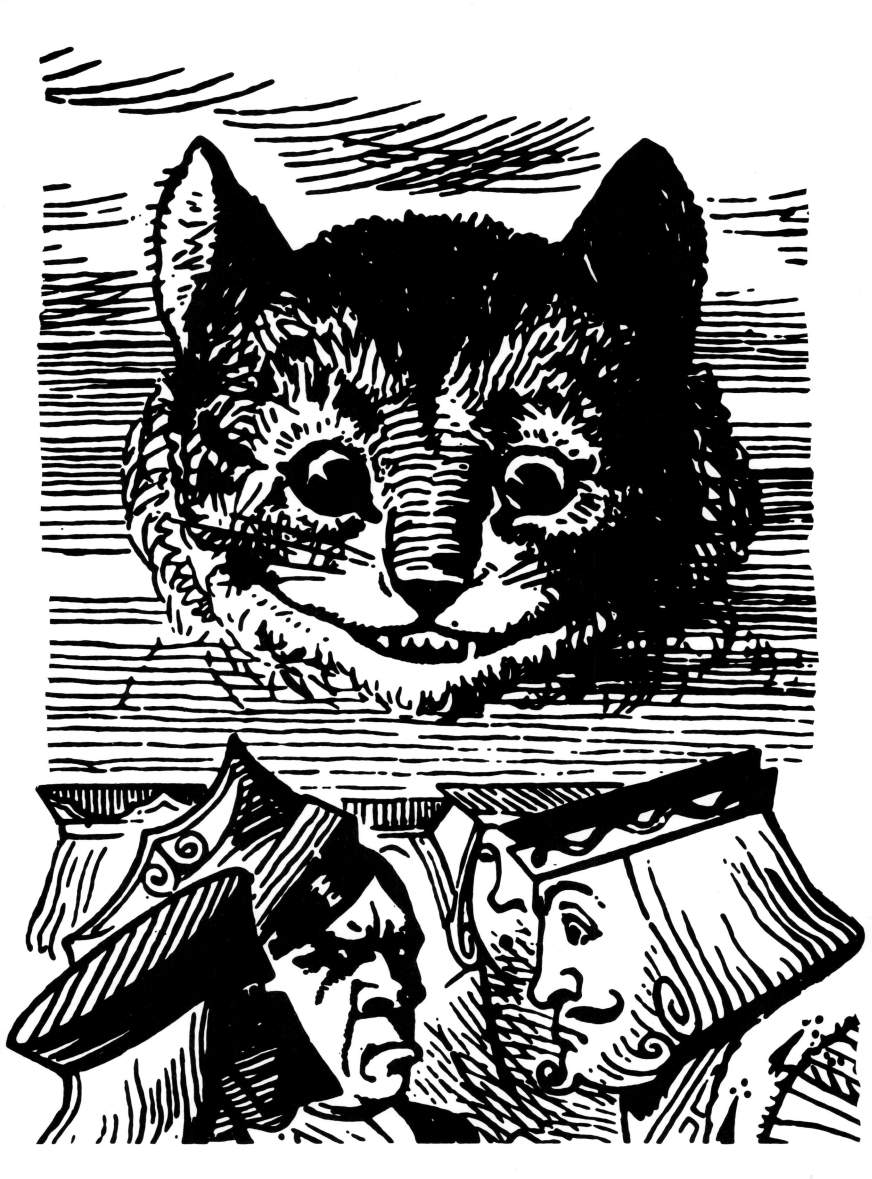

Below: Kittens learn the hard way, as Alexandre Steinlen demonstrates in these turn-of-the-century sketches, which are as instantaneous as a series of film clips. *Opposite:* Steinlen's monumental, yellow-eyed tiger cat flexes its muscles, poised like an alert boxer. Its piercing sphinxlike gaze is menacing, mysterious.

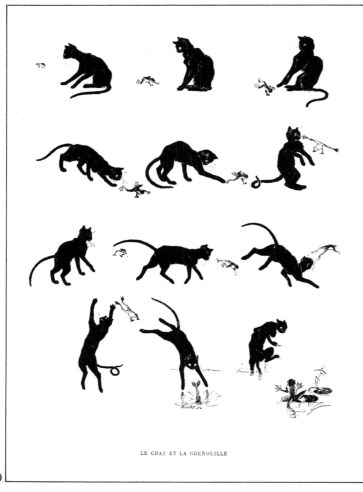

LE CHAT ET LA GRENOUILLE

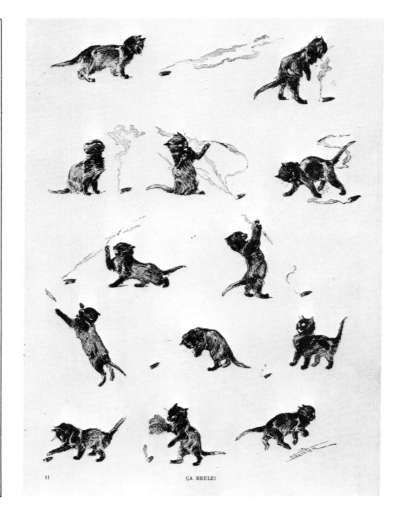

II ÇA BRULE!

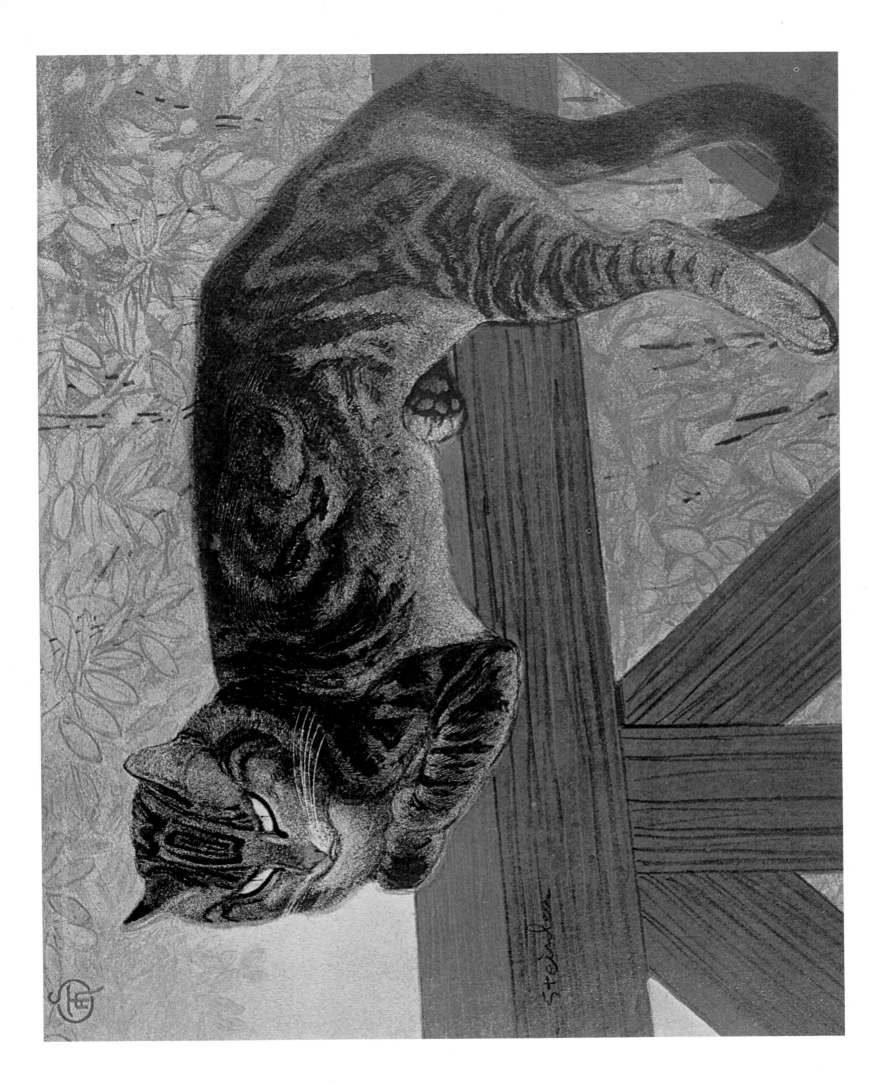

Steinlen had a passion for cats, and he drew them with incredible grace and skill, as on the cover (*opposite*) of one of his books. He used cats in countless posters and illustrations. Below is an advertisement for the sale of his prints, another for pasteurized milk, and another for chocolate and tea.

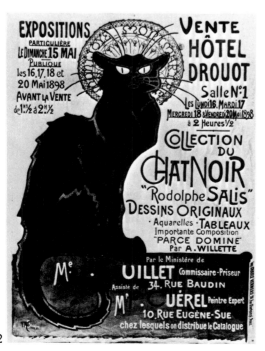

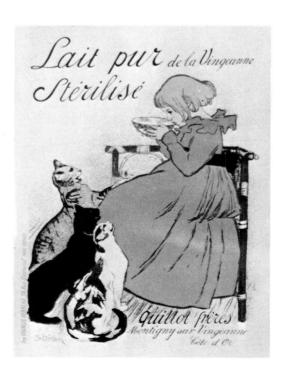

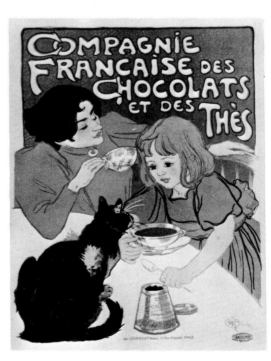

Dessins sans paroles

des Chats

par

Steinlen

PARIS
ERNEST FLAMMARION
EDITEUR
26 RUE RACINE
PRÈS L'ODÉON

Collection
Rodolphe Salis

Opposite: The style of Pierre
Auguste Renoir is ideally suited for
painting the cat, whose velvety fur
and fluid motion is so elusive to the
eye. The shimmering surfaces and
suppleness of this 1882 painting
are in harmony with Renoir's plump
models, woman and cat alike. *Below:*
One of the most fearsome cats in all
of literature is sketched by Aubrey
Beardsley, the English illustrator, for
an edition of Edgar Allan Poe's
The Black Cat, published in 1895.

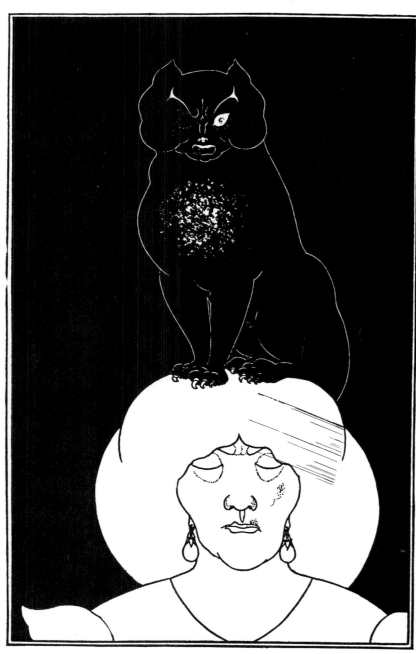

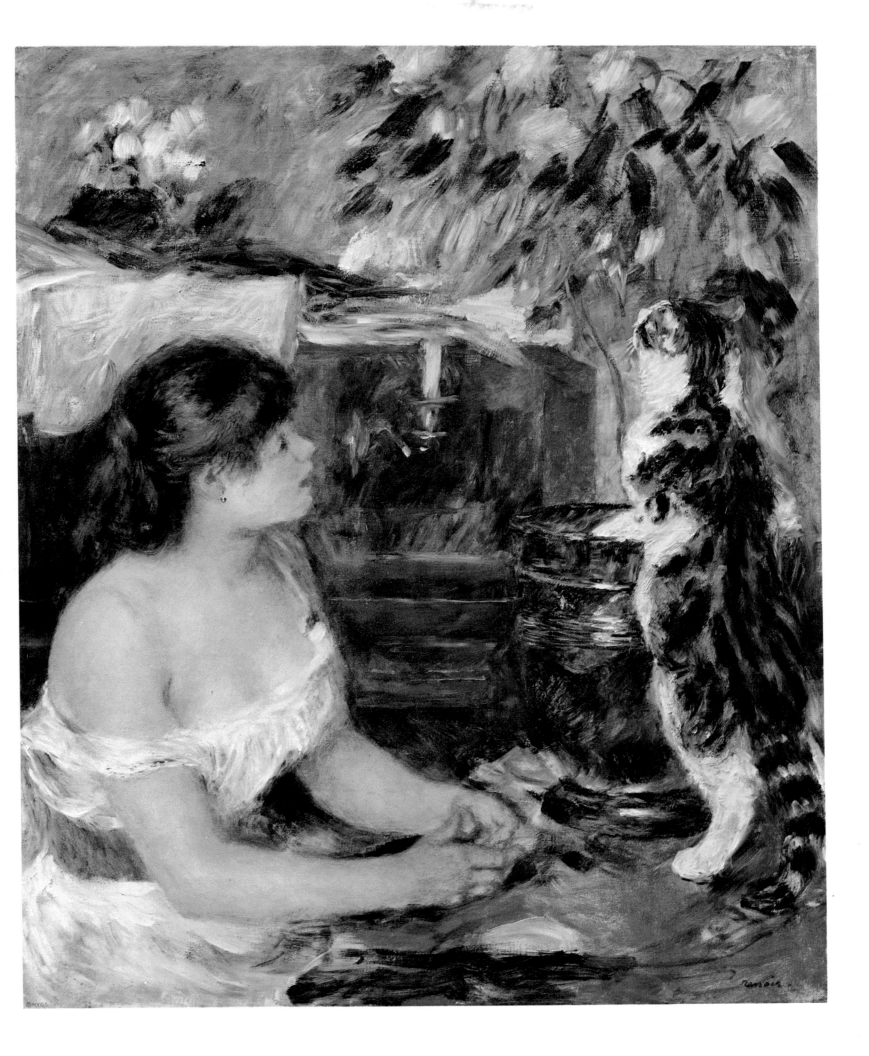

Below: Two langurous bodies—the nude and her cat—provide sleek pools of light set against black and white patterns of bedspread and pillows. Félix Edouard Vallotton carved the title of this 1896 wood-cut at the lower left, *La Paresse* (*Indolence*). Lazily, the woman strokes her hair with one hand, while she strokes her cat with the other. *Opposite:* Henri Rousseau portrays *Pierre Loti,* the French writer, in 1892. Loti smokes soberly, as the chimney stacks puff away in the background. Is Loti's cat the writer's muse and inspiration?

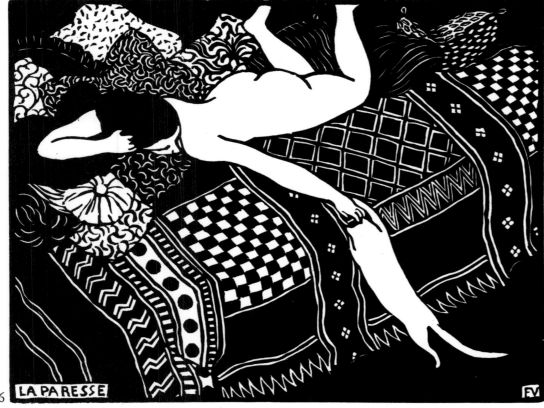

LA PARESSE

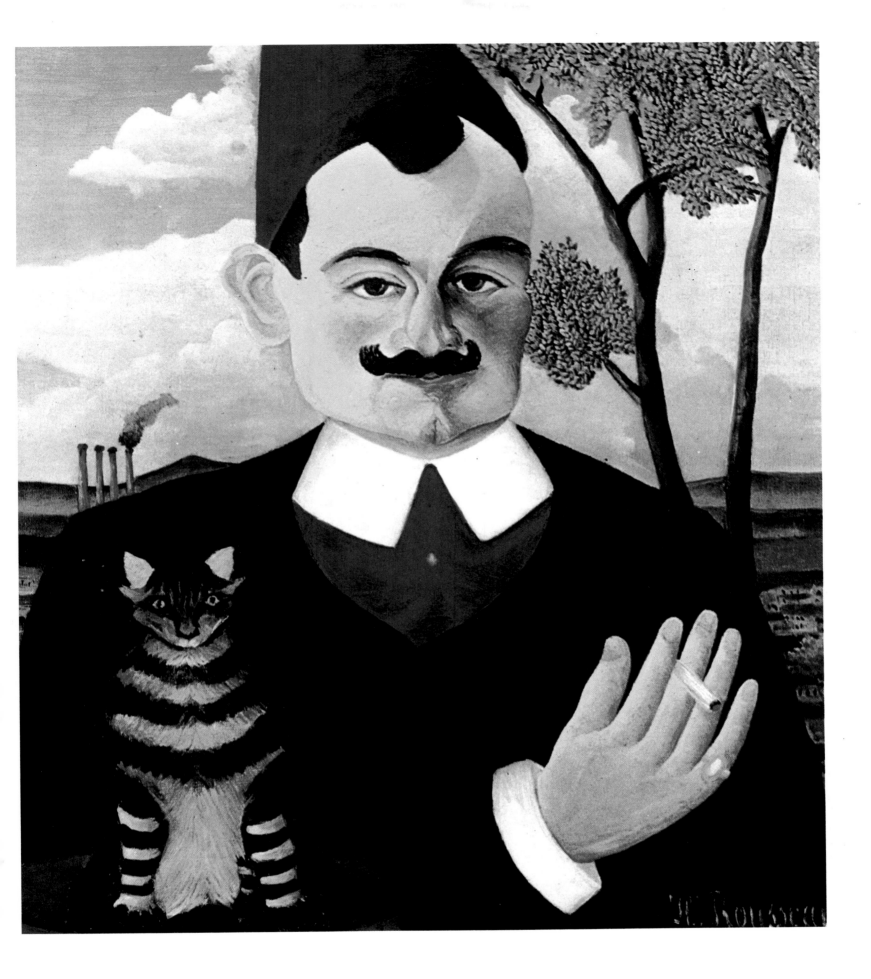

Below: Like Mary Pickford a few decades later, this golden-haired little darling by Thomas Nast was America's Sweetheart in the late nineteenth century. She sits by the fire with her pets in this charming, sentimental vignette, a nostalgic example of America's yesterday.
Opposite: This newsstand poster for a magazine was illustrated by J. C. Leyendecker in 1899. It has the brilliant verve of a Toulouse-Lautrec poster. The sinuous lines reveal the influence of Oriental art, so much in vogue at the turn of the century.

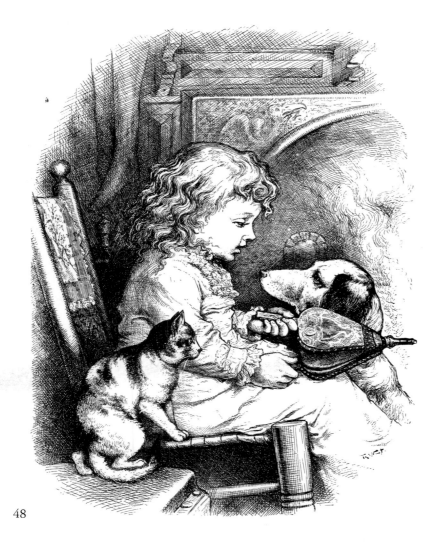

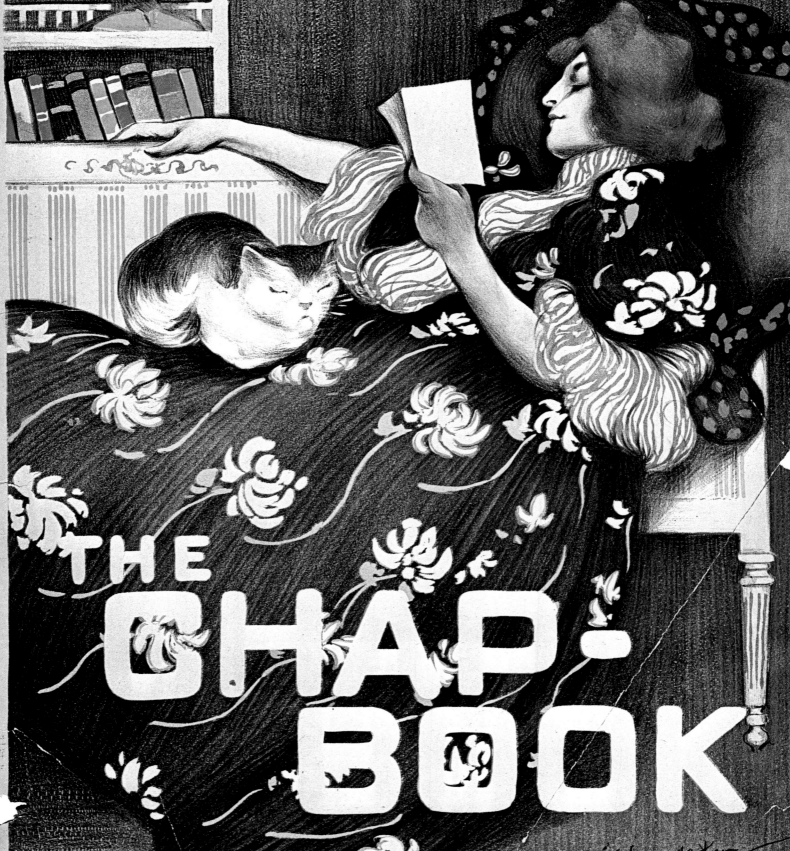

One of America's finest graphic
artists, Edward Penfield, produced
cats both fetching and dignified.
His work combines formality with
charm. The lady is reminiscent
of the Gibson Girl of the same period.
Opposite is a poster that Penfield
did for *Harper's Magazine* in 1896,
while below is the cover for an
1897 calendar, in which a cat observes
the artist at work.

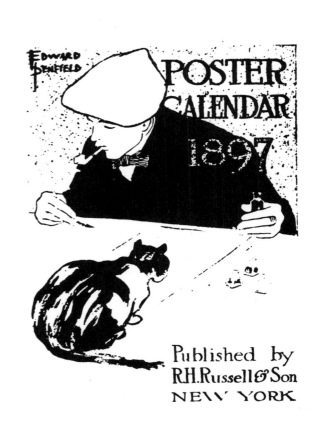

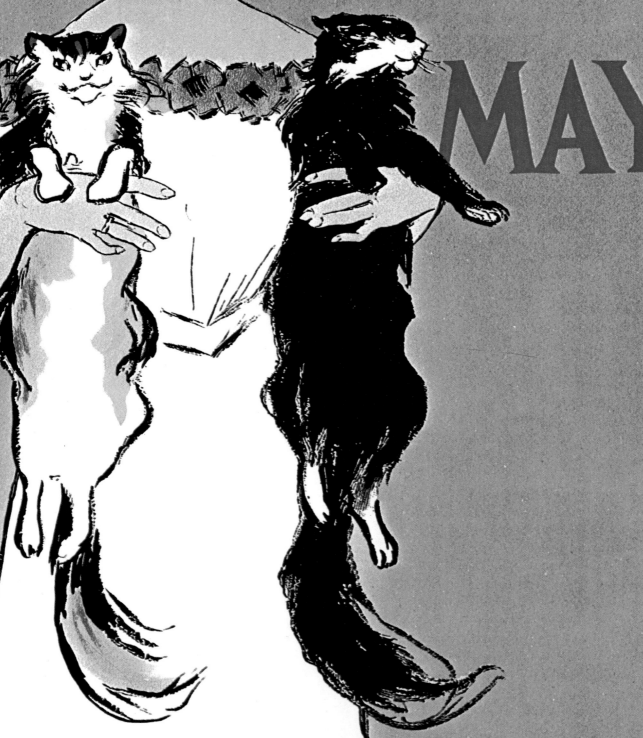

HARPER'S

MAY

Edward Penfield

The Fatal Mistake, drawn in 1894 by A. B. Frost, is like frames from a silent movie. His cartoon series shows the hideous change from sweet tabby to poisoned puss, from Jekyll to Hyde. The pet is driven to demonic depths, hounding its terrified and terrifying way to death by drowning. On the opposite page is an enlargement of one of the drawings, which are all action and energy, underlaid by savage social comment.

The Fatal Mistake

A Tale of a Cat

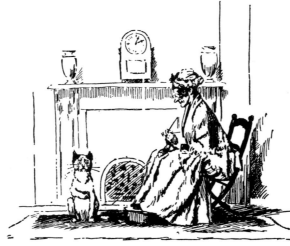

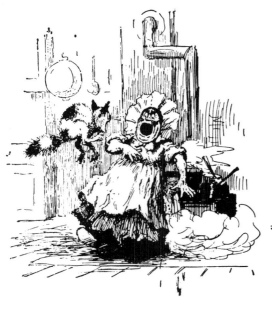

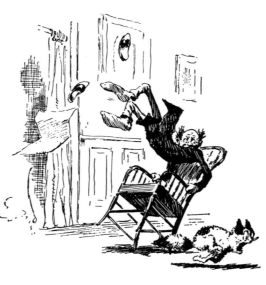

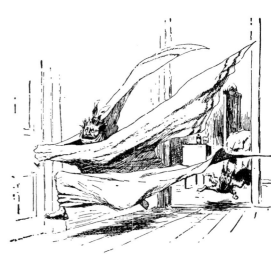

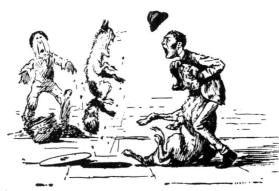

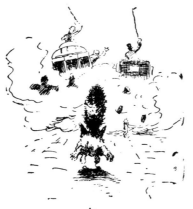

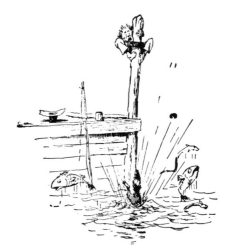

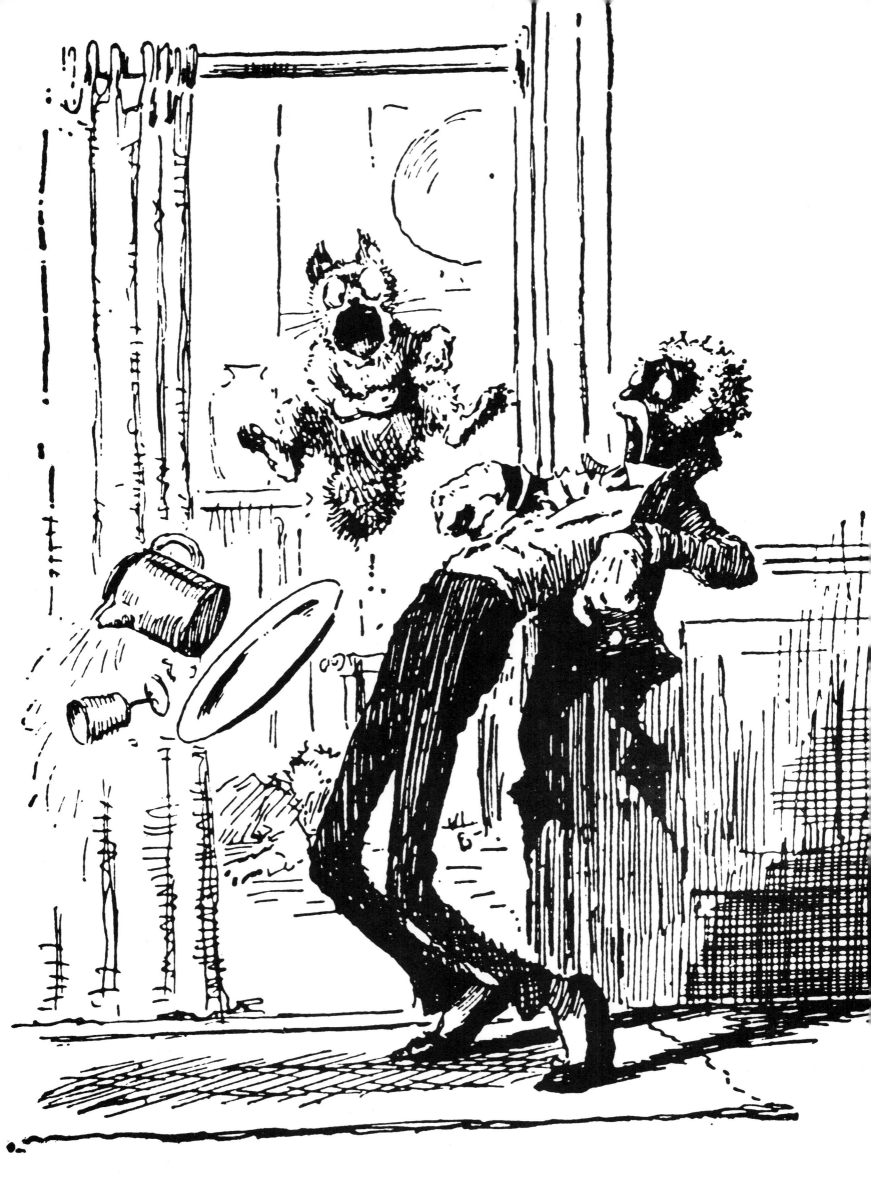

Below: Barging down the Nile in a melon boat is that languorous glamour puss Mehitabel. She waves a blossom as she fishes for her dinner, recalling her earlier incarnation as the devastating "Cleopatterer." She and Archy were enduring co-stars of the classic 1920's comic by Don Marquis, illustrated by George Herriman. They remain the Romeo-and-Juliet, the Bogart-and-Bergman of Eternal Romance. *Right:* Meet here the charmingly mad *Krazy Kat*, a hero whose kind heart and good intentions are continually thwarted by fickle fate. George Herriman created this world of sly and plaintive humor in 1911.

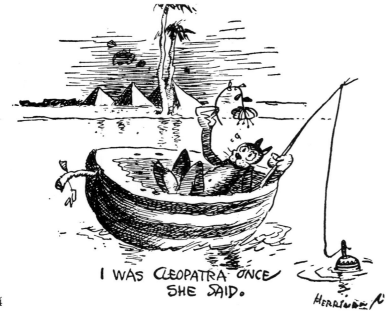

I WAS CLEOPATRA ONCE
SHE SAID.

HERRIMAN

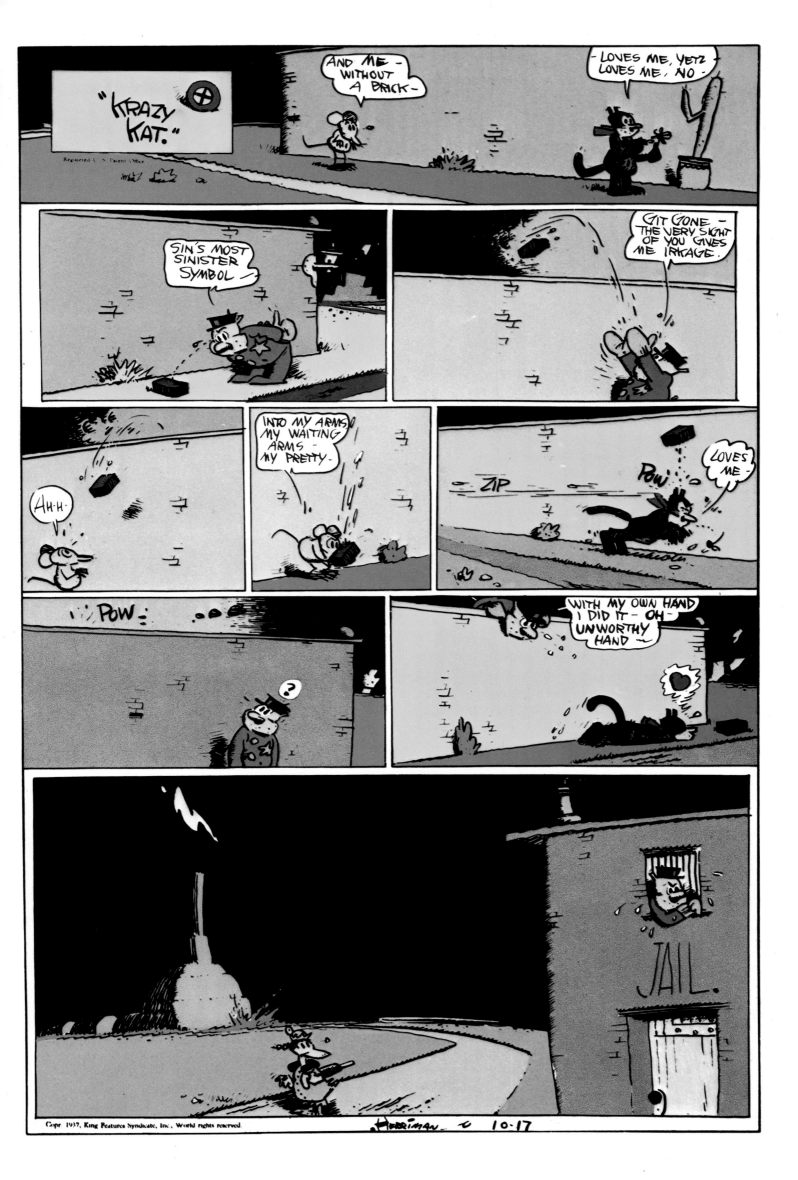

Now to the cat's dark side, here exploited for social and political purposes. *Below:* The cat's mean, predatory way of playing with its victim was dramatized here by suffragettes. They wanted to expose the nasty game of cat-and-mouse played by the British government, which toyed with the women's struggle for the right to vote during the First World War. *Opposite:* The cat goes to war. The Yanks chose this fighting cat to demonstrate how joining the Tank Corps could help win the War to End All Wars.

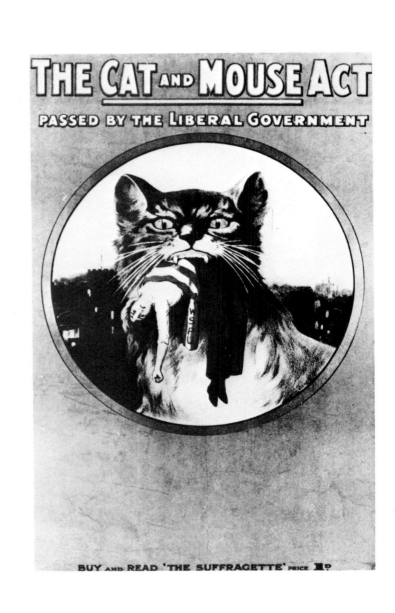

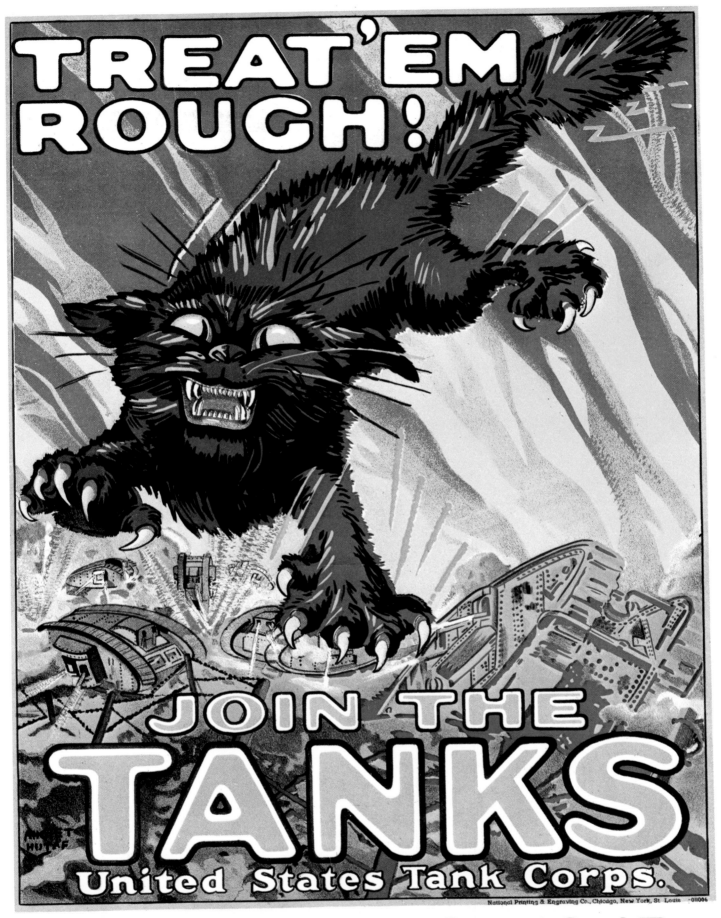

Is not the cat the most sensual of
all animals? *Below:* The French
illustrator, Herouard, who spe-
cialized in naughty ladies of the
flapper era, obviously thinks so.
Who is teasing whom, in these
peekaboo games of show and tell?
And in the calendar (*opposite*)
we get the impression that the lady
is rehearsing for more serious games
later in the evening. The coopera-
tive cat is just a stand-in.

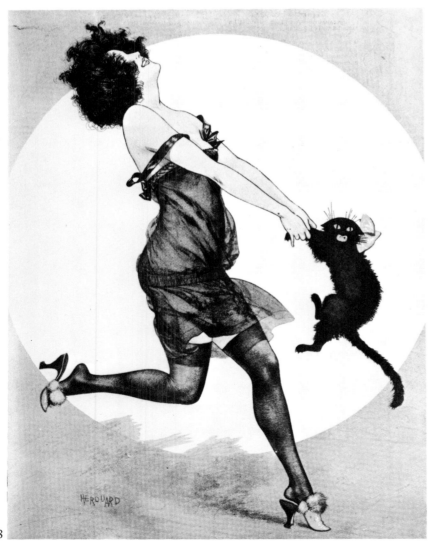

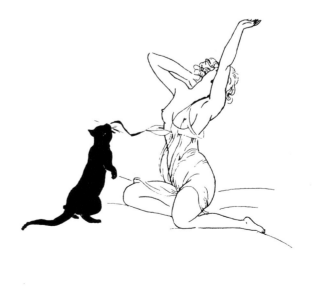

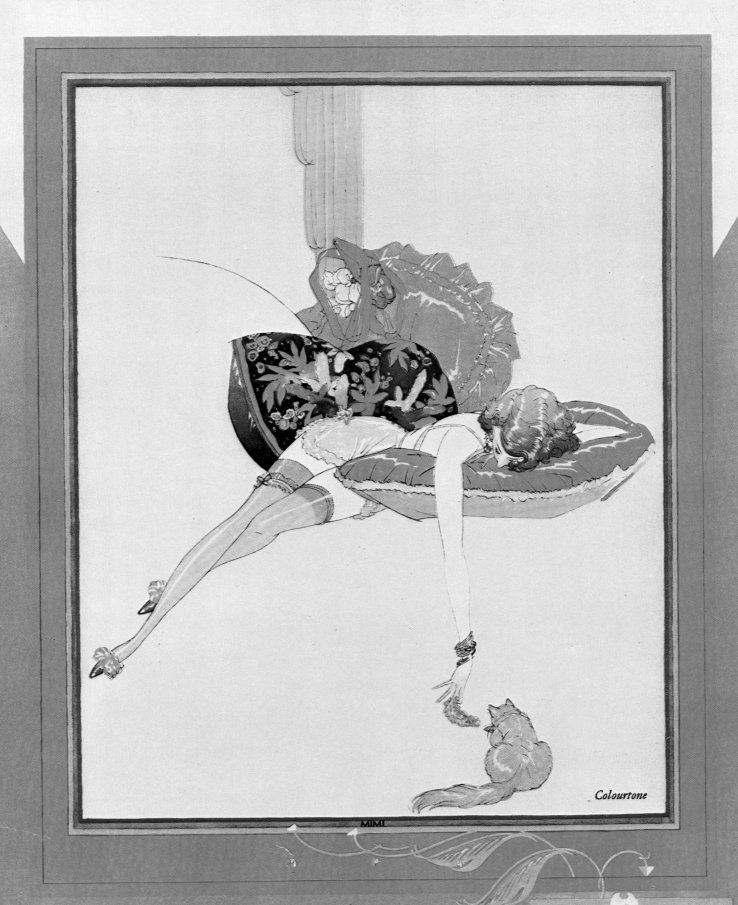

Colourtone

MIMI

Around the turn of the century, cats came to the aid of commerce. Artists put cats on cigar-box lids (*below*), chewing tobacco posters (*bottom*), and lemon crates (*opposite*). In their various moods, cats demonstrated that products were smooth-smoking, scrappy-tasting, or even nutritious. The labels have now become collector's items.

TOM CAT

BRAND

Sunkist

OROSI FOOTHILL
CITRUS ASSOCIATION
OROSI, TULARE CO.
CALIFORNIA

SHIPPED THRU
LINDSAY-MERRYMAN
CITRUS EXC.

As American as apple pie, cats go straight to the consumer's heart and pocketbook. *Opposite:* A cat is artfully employed by Norman Rockwell in a calendar, as part of a 1960 *Winter* scene of inventory-taking at a country store. *Below:* G. Gruenwald's sleeping kitten, Chessie, was selected by the Chesapeake and Ohio to purr about their railroad. Chessie, as cosy and clean as the berths she catnaps in, has symbolized the C&O since 1934 and has appeared on millions of calendars.

JANUARY 1956

SUN	MON	TUE	WED	THU	FRI	SAT
1	2	3	4	5	6	7
8	9	10	11	12	13	14
15	16	17	18	19	20	21
22	23	24	25	26	27	28
29	30	31				

CHESAPEAKE AND OHIO RAILWAY

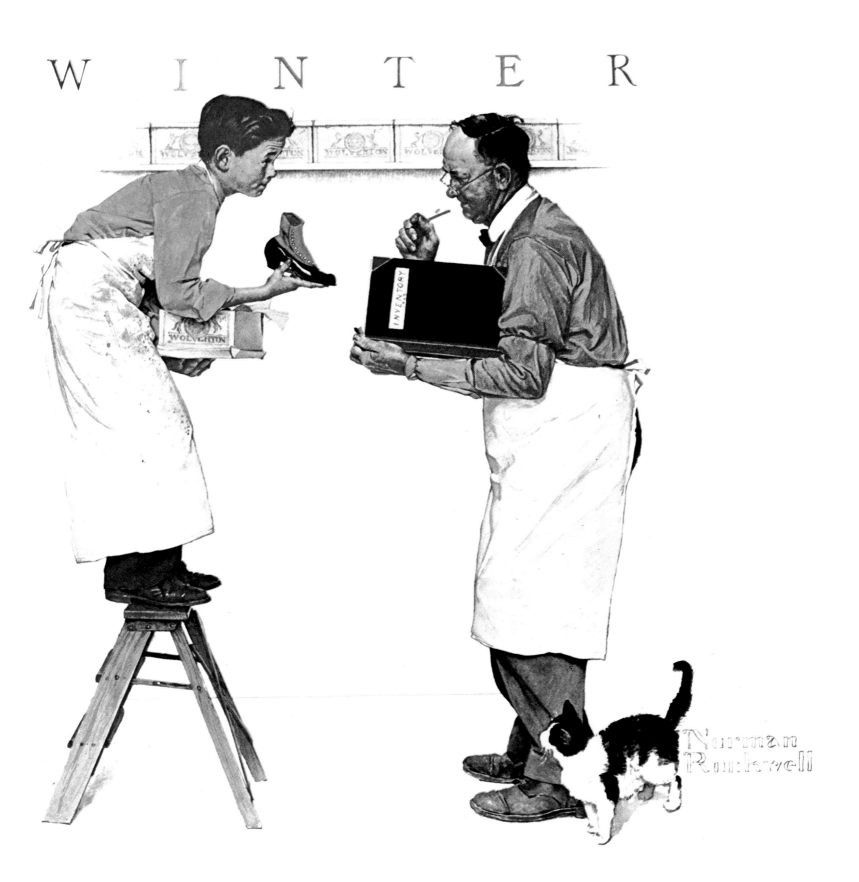

Cats have sometimes been personified, even to make a political point. In this eighteenth century Russian woodcut, czar Peter the Great is portrayed as a cat. His adaptation of western customs led him to wear a moustache (lip whiskers) instead of the conventional Russian beard. *Opposite:* What dark secrets is this brooding cat hiding from the world? Why does she sit in a hatbox, peering out at us like some sultry siren from silent films? *Surprise Contents* was painted by the Dutch artist Solomon Meijer in 1909.

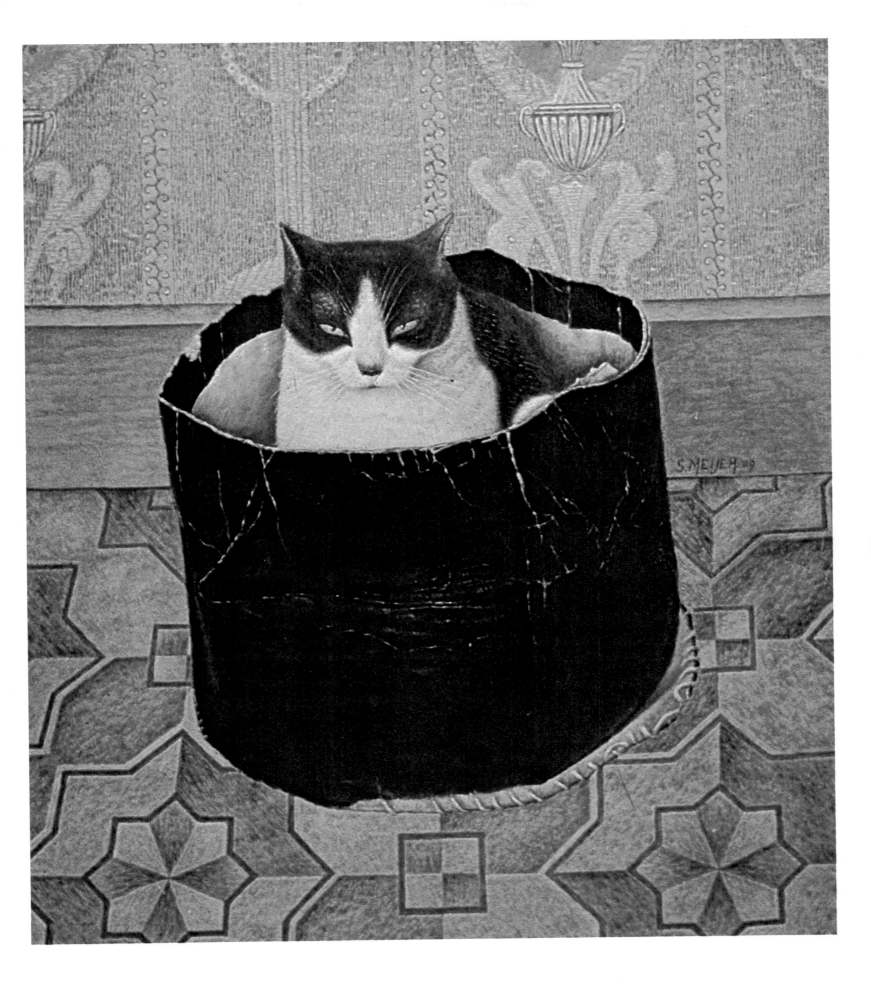

No frivolous feline, *Matthew's Cat*, painted in 1975 by the American painter Paul Davis seems to stand —or rather sit—guard, like some ancient warrior. He stares alertly ahead, ready to ring his bell to sound the alarm, then perhaps to bristle his whiskers, a very pugnacious puss indeed. *Below, right:* Bustopher Jones is a true cat-about-town. Though portrayed here in silhouette, Bustopher is known for his formal black tie and jauntily twirled mustache, as debonair as Fred Astaire. The illustration is by Nicolas Bentley for T. S. Eliot's *Old Possum's Book of Practical Cats*, 1939. *Below, left:* Paul Klee, the contemporary Swiss painter, has conjured up this mysterious cat that has but one thing on its mind, a bird.

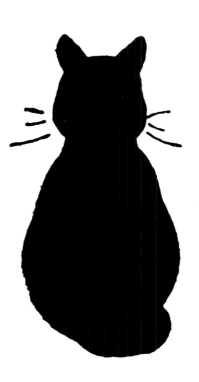

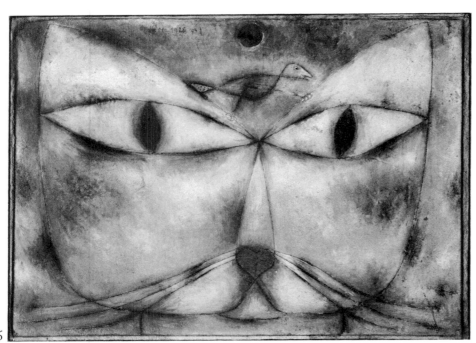

66

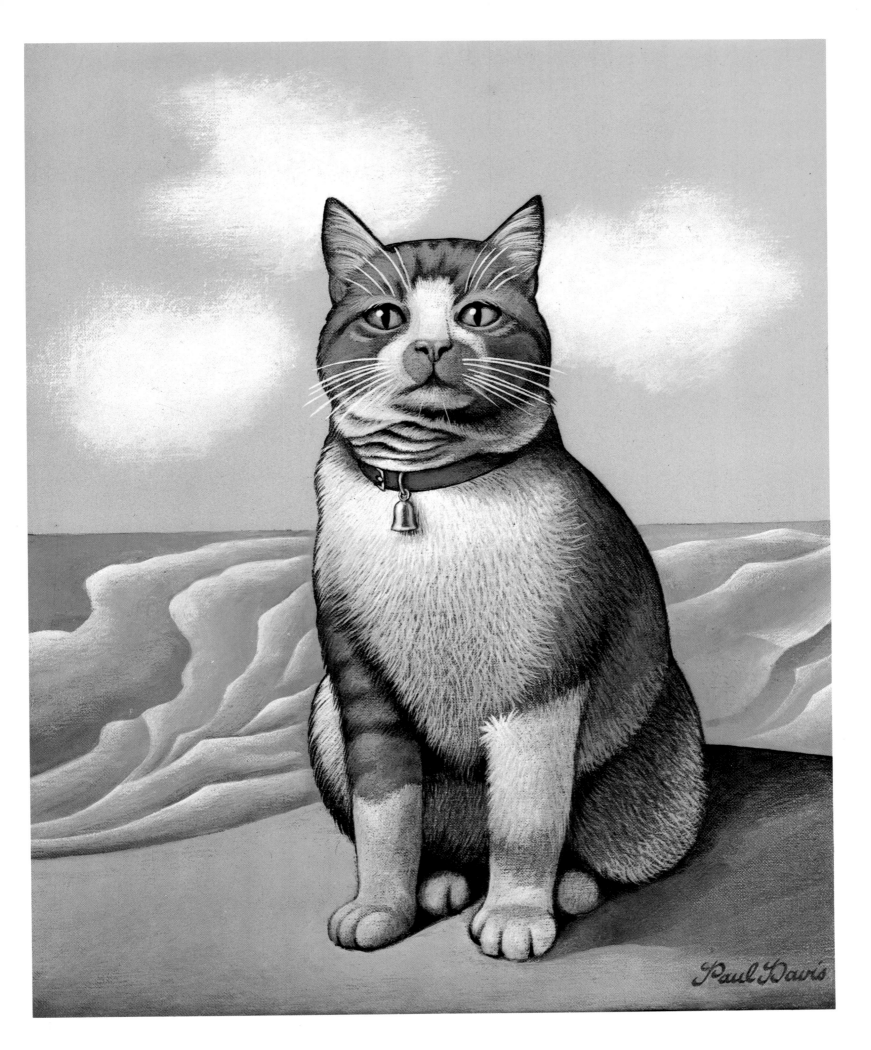

Cats get all the wittiest lines in
these drawings (*right*) by Beatle,
John Lennon, in 1964 and (*below*)
by Ralph Steadman, 1976. *Opposite:*
A Ronald Searle fat cat wonders
who got to the fish first. Like the
hands of a clock, the flick of each
whisker tells us what kind of a time
each cat is having.

68

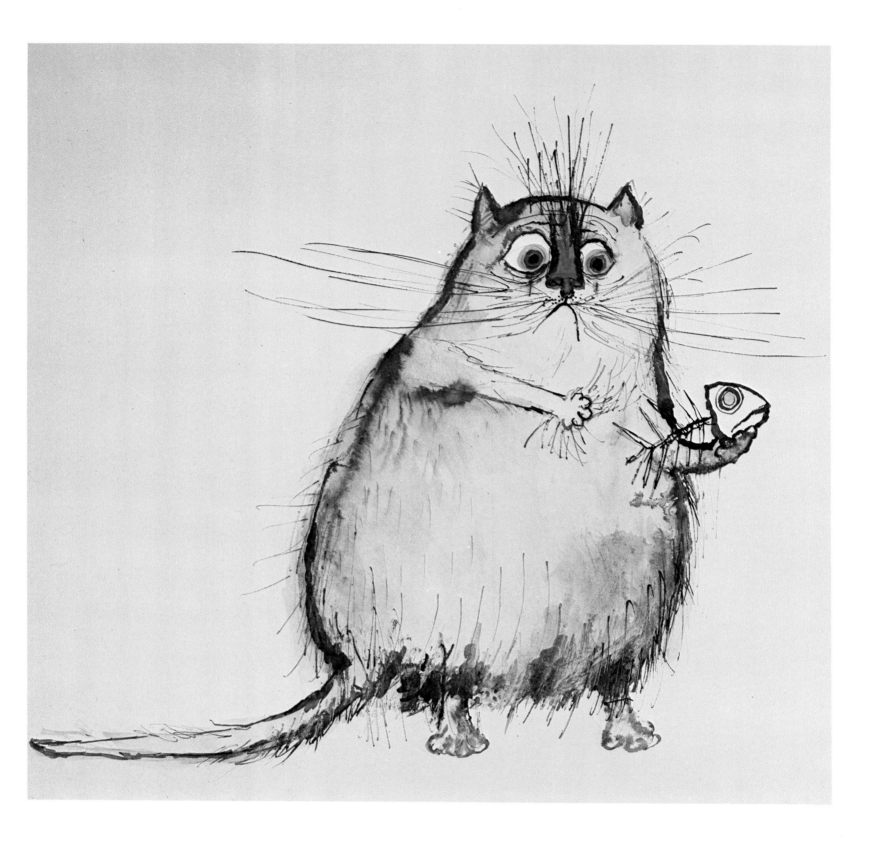

Pablo Picasso created the etching below in 1942, to illustrate a text written by the eighteenth-century naturalist. Picasso delineates here a philosopher-cat, as enlightened and serene as the century he supposedly lived in. Quite a different beast indeed is the ferocious image of the cat on the opposite page, painted by Picasso with bold, fierce lines and earthy colors. How far, Picasso seems to be asking, has the cat really come from its predatory jungle habitat?

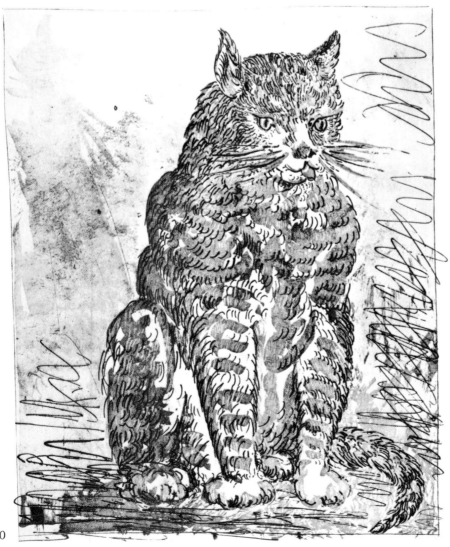

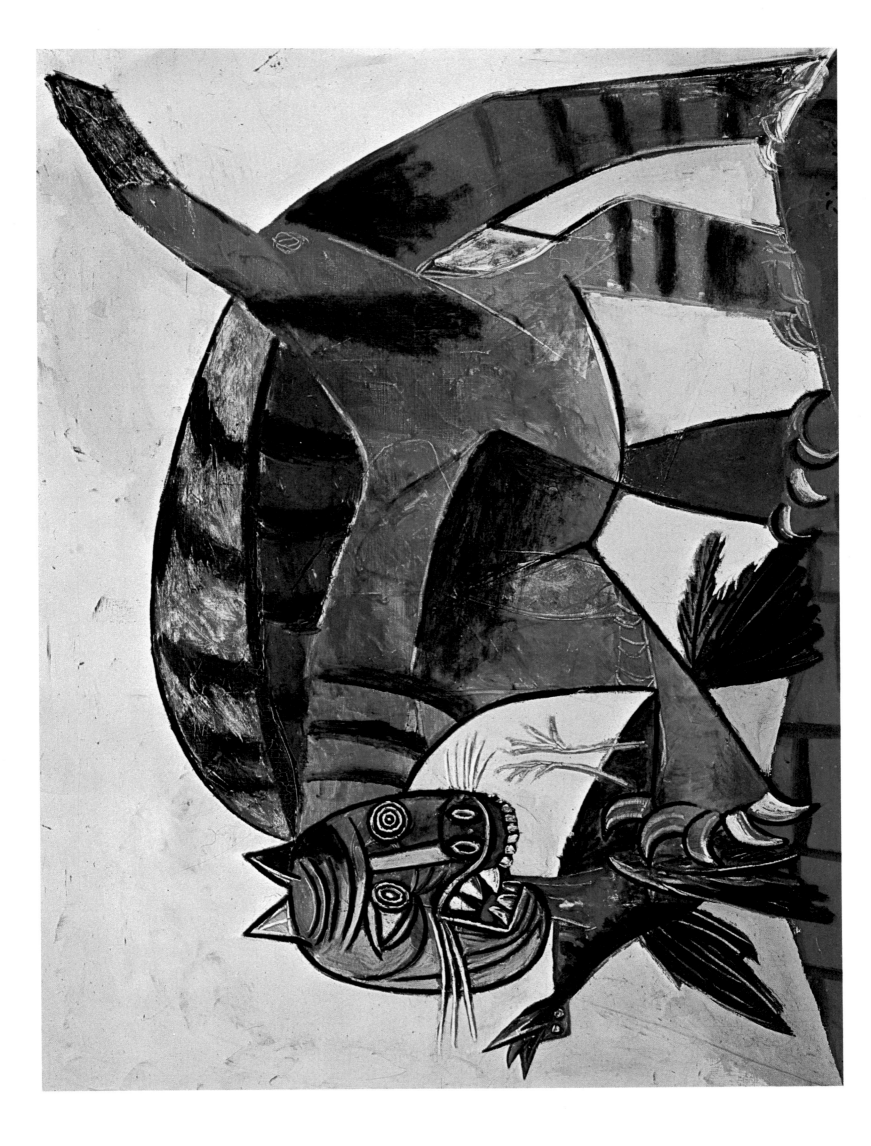

And, finally, the happiest of cats: Contemporary illustrator and cartoonist, Tomi Ungerer, performs magic with his pen by converting sardines into mice. What a pleasant dream for any cat who might be dozing by the fire after a long day exploring in the garden for such small, unpalatable creatures as ants and grubs. This is the end of a cat's perfect day.

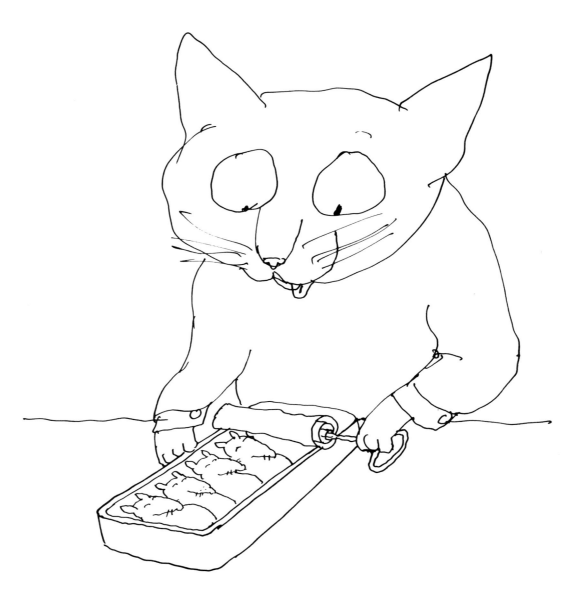

ACKNOWLEDGEMENTS:
5 Poster, courtesy Alan Trachtman, New York.
13 Jean-Baptiste Greuze, *The Wool-Winder*. The Frick Collection, New York.
15 Goya, *Don Manuel Osorio de Zuñiga*. Metropolitan Museum of Art. (Gift of Jules Bache).
19 *Kitty*. The Metropolitan Museum of Art. Gift of Mrs. E. C. Chadbourne, 1952.
23 Morris Hirschfield, *Angora Cat*. Collection of the Museum of Modern Art.
25 Joan Sloan, *Backyards, Greenwich Village, 1914*. Courtesy Whitney Muesum of American Art, New York.
26 Flora E. Bailey, *Kittens Examining a Mouse Swimming in a Milk Bowl*. Collection of Mrs. Milton Gardiner.
 Artist Unknown, *Cat with Mouse*. Collection of the Robert Hull Fleming Museum, bequest of Henry Schnackenberg.
 Artist Unknown, *Cats Playing with a Spool of Thread*. Collection of Dorothy D. McKenney.
 Artist Unknown, *Study in Gray and Black*. Collection of Mr. and Mrs. Dana Tillou.
27 R. P. Thrall, *Minnie from the Outskirts of the Village*. Courtesy of the Shelburne Museum, Vermont.
28 Artist Unknown, *Jerusha Holding Lucifer*. Collection of Mr. and Mrs. Julian L. Gailey.
29 William Thompson Bartoll, *Girl and Cat*. Abby Aldrich Rockefeller Folk Art Collection, Williamsburg, Va.
30 Attributed to Joseph Goodhue Chandler, *Boy with Cat*. Collection of Dr. and Mrs. Ralph Katz.
 Artist Unknown, *Girl in Blue with White Cat*. Collection of Mr. and Mrs. Burton E. Purmell.
 Artist Unknown, *Baby in Blue*. National Gallery of Art. Gift of Edgar William and Bernice Chrysler Garbisch.
 John Bradley, *Little Girl in Lavender*. National Gallery of Art. Gift of Edgar William and Bernice Chrysler Garbisch.
 Ammi Phillips, *Girl with Cat* (Miss Catherine Van Slyck Dorr). Courtesy of the Amon Carter Museum of Western Art, Fort Worth, Texas.
31 Ammi Phillips, *Girl in Red with her Cat and Dog*. Private Collection.
32 Hsüan Tsung, *Spring Frolic in a T'ang Garden*. Metropolitan Museum of Art, Fletcher Fund, 1947.
33 Toko, *Cat*. The Metropolitan Museum of Art. Gift in Memory of Charles Stewart Smith, 1914.
35 Hiroshige, *Cat Bathing*. Freer Gallery, Smithsonian Institution, Washington. Harris Whittemore Collection.
45 Pierre Auguste Renoir, *Girl with a Cat*. National Gallery of Art, Washington. Harris Whittemore Collection.
55 King Features Syndicate, Inc.
65 Salomon Meijers, *Suprise Contents*. Stedelijk Museum, Amsterdam.
69 Courtesy John Locke.
72 Copyright © 1970 Tomi Ungerer.

Back cover: Andrew Wyeth, *Miss Olson*. Courtesy Whitney Museum of American Art, New York.